Reinventing Tradition in a New World
The Arts of Gu Wenda, Wang Mansheng, Xu Bing and Zhang Hongtu

Wang Ying and Yan Sun

October 7th 2004–December 15th 2004
Schmucker Art Gallery
Gettysburg College

The exhibition *Reinventing Tradition in a New World: The Arts of Gu Wenda, Wang Mansheng, Xu Bing and Zhang Hongtu** is organized by Gettysburg College, Pennsylvania. We are grateful for the generous support of the Freeman Foundation. Other funding is provided by Gettysburg College.

*The name of the artists is listed in alphabetic order.

Curators: Yan Sun, Wang Ying
Supervisors: Katheryn M. Linduff, Mark Warwick
Gallery Director: Molly Hutton
Book Design: Steve Westfall
Manuscript Editor: Bhuva Narayan

ISBN 0-9759707-0-4

Table of Contents

Foreword

Reinventing Tradition in a New World: The Arts of Gu Wenda, Wang Mansheng, Xu Bing and Zhang Hongtu at Gettysburg College is a celebration of the artistic achievements of four artists. All of these artists were born in China and eventually took up residence in New York City, where they still live and work. This exhibition, along with *Out of Time, Out of Place, Out of China: Reinventing Chinese Tradition in a New Century*, at the University of Pittsburgh, brings together the works of these four artists, all of whom experienced traditional China, especially the intellectual legacy of classical books and calligraphy; the conditions of socialist China including the Cultural Revolution; and immigrant life in America. Not without personal conflict over the memory of restrictions and devaluation of their work and ideas before leaving China, their current work creates a dialogue between that past and its artistic and cultural traditions and the modern transnational world.

It seems to me that one dominant issue that engages each of these artists is the communicative and associative power of language, both the written word and forms of artistic language. As a former emblem of the ruling class and their authority, the Chinese language was transformed and redesigned after a century of mass revolution and education and has reemerged as a performance rather than a private art. For these artists, language including its manner of presentation has become both an icon of the past as well as a fulcrum for debate and dialogue with the present.

Words and their significance, whether conventional and readable or fictional and indecipherable, as well as the manner of the brush used to create them, are fundamental staples of each individual's creative vocabulary. All engage in a back and forth discourse between identifiable Chinese and western European visual models, techniques and the formal language of the visual arts, between the past and present, between cultures and periods. Clearly the Chinese past has empowered and inspired them, while the international world in which they now live and exhibit has engaged them with questions about cultural and personal identity and where they belong, about cultural and political boundaries and the blurring of them, about reality and fiction, about what is of value and why? As artists who have grappled with many aspects of their past and their present, including the Communism under which they grew up, the culture and traditions that have survived Communism, and their own roles as Chinese-born, New York artists looking towards the future, they recognize the usefulness of the social and artistic message of language and its ability once again to empower and engage its users and observers.

As with all artists, the work of art at any moment represents where each is in a process of discovery and self expression. In this case, some of the works exhibited are part of a series, and command a particular position in that sequence. From Gu Wenda's the *united nations series* we see hair installations (Pittsburgh) and two of the massive stone stele series (Gettysburg) shipped from Shanghai; Wang Mansheng brings us brush paintings from his Lotus series and figure paintings; Xu Bing exhibits new machinations of square word calligraphy; and Zhang Hongtu has sent paintings from the *shanshui* series. In addition we can see that other, very different types of objects have accompanied those in series: Xu's 3D landscape painting or Gu's neon language, Wang's seals, and new sculpture from Zhang. Working in different styles is not unusual for a single traditional Chinese artist, and all of these men are capable of that sort of diversity and talent. What is so surprising is that they do so in so many distinctive media.

The exhibitions are the brainchild of Yan Sun and Wang Ying—they chose the artists to include; they conducted interviews with them; and they wrote essays for the catalogue as well as invited others to participate. The exhibitions are taking place simultaneously and viewers who can should see both. I want to acknowledge the creative work of the co-curators as well as the managerial capacities and patience of the Gallery Directors both at Gettysburg (Molly Hutton) and Pittsburgh (Josie Piller) who not only carried out the difficult task of planning, securing and installing the objects, but also of dealing with the many personalities involved and with programming events around the shows. Note must also be made of the generous funding supplied by the Freeman Foundation Grant at Gettysburg. The availability of these funds made this happen. At the University of Pittsburgh Gallery, funds were supplemented by grants from the Asian Studies Program, from the College of Arts and Sciences, and the Graduate Program in Arts and Sciences.

We have exhibited four individual visual artists who are fully engaged with and emerging in the contemporary art world as major players. In my view, it is a privilege to be able to assemble, examine, and now compare their works directly. In their own unique way, each tells us a bit about the contemporary world and his place in it.

Katheryn M. Linduff
University of Pittsburgh

Acknowledgements

Gettysburg College is pleased to bring these four artists to the campus. The Schmucker Art Gallery in the Department of Visual Arts is a great resource for students to connect with the ever-changing world of contemporary art. We hope this exhibition will not only add to Gettysburg's excellence in the visual arts, but also enrich her legacy. We are deeply grateful for the support from Freeman Foundation that enables us to provide this great opportunity for our students to learn about the multicultural world we all live in.

During the year-and-a-half of preparation for the show, we have received great support from our friends and colleagues. We would like to express our gratitude to Mark Warwick, Chair of the Department of Visual Arts at Gettysburg College. He has worked with us beginning with the proposal for the show and has given invaluable suggestions and support on every detail. He is also a great colleague to work with. Our special thanks also go to Molly Hutton, Director of the Schmucker Art Gallery. She has patiently assisted us with the transportation, insurance and installation of the artworks. We greatly appreciate the effort of Daniel DeNicola, the Provost of Gettysburg College who has worked with the Freeman Foundation to ensure financial support for the show. We thank Mr. Qian Zhijian, whose advice was invaluable. Finally, we are indebted to Prof. Katheryn Linduff of the University of Pittsburgh, without whose advice and guidance, this project may not have come to fruition. Last but not least, many thanks to Bhuva Narayan for her patience and for her efficient editing of the manuscript.

Forever and foremost, we want to express our gratitude and great appreciation for the cooperation and enthusiasm of the four artists: Gu Wenda, Wang Mansheng, Xu Bing, and Zhang Hongtu. We admire and respect their professionalism, commitment and dedication.

Yan Sun
Department of Visual Arts
Gettysburg College

Wang Ying
Department of Art History
University of Milwaukee-Wisconsin

Introduction

Reinventing Tradition in a New World: The Arts of Gu Wenda, Wang Mansheng, Xu Bing and Zhang Hongtu brings the artworks of four unique contemporary artists.[1] They were all born in China, but now live and work in New York. In the early 1980's, Gu Wenda and Xu Bing emerged as two pioneer artists who challenged the paradigm and notion of traditional Chinese art. They challenged the notions of why, what and how with regards to traditional and contemporary painting. Gu Wenda's large-scale ink paintings with pseudo-seals and invented Chinese-script-like characters are not only his bold creation of a new form of painting, but expressions of his rebellious attitude toward orthodoxy and the oppression of individualism through the blind following of tradition. Xu Bing's suspicion of conventions is articulated and indicated by *A Book from the Sky* (1987-91), a breathtaking installation of large-scale books spread on the floor and suspended from the ceiling, written with 4,000 characters, all individually carved on wooden blocks in reverse and painted by hand, but which has no literal meaning.

However, in the late 1980s, both artists abandoned their position as professors at the two most prestigious Chinese academies, the Central Academy of Fine Arts in Beijing and the Zhejiang Academy of Fine Arts, in order to come to the United States to search for new ways of expression and alternative perspectives to view the position of Chinese art in the art world, and their own positions within it.

Zhang Hongtu was the first of these four artists to arrive in New York. With "guilty" and mixed feelings, Zhang started working on his Mao series of paintings (more commonly known as *Material Mao*) during the late 1980's and early 1990's as a way of psychotherapy, a way of debriefing himself from the values that were induced or inculcated in him as an artist living in China. This series firmly established his artistic identity in the West.

Wang Mansheng, the youngest among them, found a different path to art. Trained in classical Chinese literature and having served as an editor at the China Central Television Station where he produced programs on Chinese and Tibetan Art, Mansheng was strongly interested in art, and when he moved to the United States in the mid 1990s, he found the freedom and the inspiration to launch his own career as an artist.

All the artists in the show had to start over from scratch in the United States by consciously re-identifying who they were and what kind of art they wanted to create. All of them, however, still hold on to their original artistic goals and inspirations: to create works of art that comes from their hearts. Art is not just a career for them but a life they choose to live in.

Today, Gu Wenda, Xu Bing and Zhang Hongtu are all well-known in the world of contemporary art, while Wang Mansheng's paintings, in keeping with the tradition of China's gentleman scholars, are often quiet contemplations on the landscapes and images of China's past that constantly remind us of his artistic integrity and temperament as a scholar and educator who enjoys the expressive possibilities of ink and color on various types and textures of materials. The artworks exhibited here at the art gallery of Gettysburg College present these four artists' unique viewpoints on the cultural differences between the East and the West and their own search for an ideal artistic language for universal communication.

Gu Wenda's two steles from the *Forest of Stone Stele* series are powerful and monumental. These two pieces each display a well-known 8th century Tang poem in the form of an English retranslation based on a phonetic translation of the Chinese characters, back-translated from an original English translation of the poem, along with a rewriting of the poem in English by Gu himself. The steles condense the essence of traditional Chinese stone-carving, skillfully executed with a solemn contrast of the light-colored Chinese and English calligraphies carved into the dark and smooth surface of the stone. These artistic features perpetuate the meaning and ideas that bounce back and forth between the English and Chinese translations of the original Tang poem.

Xu Bing's distinctive take on today's multicultural environment is presented through his own invention, the Square Word Calligraphy composed of carefully structured English words in the style of the Chinese *Kaishu* or formal scripts. In addition to traditional hanging scrolls, Xu Bing's new calligraphy is also stored in a computer and allows the audience to print it out. This questions our assumptions about traditions, art, and technology, as it truly blurs the boundaries between traditional Chinese art forms, language, calligraphy, and modern computer technology. Mao's quotes and the English

poems incorporated in Xu Bing's new calligraphy are not only visually appealing, but make us ponder the questions of who we are and how we define our cultural identity. Their meaning far transcends the language of the calligraphy itself.

Zhang Hongtu is an idealist as are Gu and Xu. His presentation of the traditional Chinese *shanshui* in the brushstrokes of Impressionist or Post-Impressionist style intermingles the Eastern and Western artistic expressions. The pairing of well-known *shanshui* painters with Monet, Van Gogh and Cézanne convey a provocative transformation of traditional Chinese painting itself. The paradox created by form, color, brushstrokes and the composition provoke questions like: What is traditional Chinese painting? What is Western painting? What are the boundaries and confluences between them?

Wang Mansheng's light-as-a-feather brushstrokes in ink and color on paper depicting lotuses, with nature in its subdued elegance, are metaphors for his own temperament and passion for nature and life. The motif, though traditional, is transformed through composition, brushstrokes and use of color which are all innovative and mean to communicate the beauty and peace of nature to audiences of different cultural backgrounds, all coming to the bustling city of New York from all over the world. Wang's paintings seem to take the viewer to a pure, remote, peaceful, and ideal world within their hearts and minds.

More than two thousand years ago, the Chinese philosopher Lao Zi (Lao Tzu) said: The loudest voice has no sound; the largest shape has no form; spirit travels far beyond the material world. We truly believe that the art of all these four artists appeal to this spirit.

Yan Sun
Department of Visual Arts
Gettysburg College

Four New Yorkers and Their Many Worlds: The Arts of Gu Wenda, Wang Mansheng, Xu Bing, and Zhang Hongtu

Wang Ying
Department of Art History
University of Wisconsin-Milwaukee

Tradition, invention, and renewal; desires, dreams, and reality. What a complicated world we live in. When one migrates to a different country, especially from a Communist country to a Capitalist one, from an ancient civilization to the New World, life seems more complicated than ever. Gu Wenda, Wang Mansheng, Xu Bing, and Zhang Hongtu are all artists who have been through this experience. What is the point of developing an exhibition of these four China-born artists who have been living in New York for decades? What are their works about and why is it worthwhile for people in America to view them? This exhibition will tell us how ancient civilizations influence the current world and how immigrants bring their cultures along with them and adopt new ones. Moreover, we see how tradition is being recreated in a diverse cultural environment, and enriches the lives of people from many worlds.

The Nature of Contemporary Arts in China

In 1890, in an essay titled "Definition of Neo-Traditionism" in the magazine *Art et Critique*, Maurice Denis urges artists to be thoughtful in their representations, to break through the conventions of "realism" or "naturalism" or whatever aesthetics was taught to them in the art academies of their time. Although more than a hundred years have elapsed since, these words are still relevant, and are reflected in this exhibition, *Reinventing Tradition in a New World*, which brings together some of the works of New York-based artists Gu Wenda, Wang Mansheng, Xu Bing, and Zhang Hongtu who were born in four different areas of China before they were drawn into the New World. They all consciously and intentionally break through all the rules or "traditions," while simultaneously building on the very same tradition with their own insights and creativity.

The artworks in this exhibition were all created after the artists left China, thus making their art significantly different from the art of those contemporary artists who live and work in China, and yet, these artists are always grouped together with contemporary Chinese artists. The question is: What is the nature and character of their art compared with those who have been living in China and with those of other American artists? It is necessary to understand what happened in China during the period we call "Modern," and examine what we call "Contemporary Chinese Art".

The Qing Dynasty ended in 1911—it was the last of a whole series of dynastic periods in China that spanned more than 4000 years. A republican form of government was established, but soon crashed as a result of civil wars. Many regional lords came to power and the central government was no longer functioning as a republic. However, during this period, even under the rule of military lords, "culture" was one of the aspects that all rulers wanted to claim in order to proclaim their role in "modernization" and "civilization." The term "civilization" acquired a new meaning at that time, which does not refer to the ancient ones, but to a process of modernization. For example, Liu Haisu, an artist who had established one of the earliest Western-style fine-art schools in China, was forbidden to use nude models in his class, leaving him to state in public how a modern government, which does not understand the function of nudity in art education, can understand "culture". This statement was enough to make the military leader immediately withdraw his order. The president of Beijing University, Prof. Cai Yuanpei, strongly proposed: "Let art replace religion." This major policy has been practiced in elementary schools in China since then. Much of Western philosophy, literature, visual arts, drama, and music were introduced into China during the late nineteenth-century and into the 1930s. Many Chinese who had been educated in Europe, America and Japan (which was open to the West by that time) returned to China and rediscovered China's own native treasures. Ancient Buddhist caves, such as the Dunhuang Grottos, became a valuable resource for many who engaged in visual art and in studies of religion and history. Many of these returnees traveled to remote areas to study ethnic and folk cultures, thus preserving some art forms of music and dance, and made the majority ethnic Chinese become aware of these treasures [2]. Many films were made during that time which glorified the regional ethnic and cultural minorities in an attempt to present these hidden treasures of China to the majority population.

China in the 1930's had its own social problems, but it was one of the very open periods in Chinese history, when China was more open to, and more accepting of, the rest of the world. Many new academies of arts and sciences were founded which reflected modern Western society and brought them into the mainstream. Writing styles changed from classical to colloquial, and grammar was influenced by Latin during this institutionalized process. Even today's spelling system as used on the mainland (pinyin) was built upon Latin. Young Chinese writers were not only influenced by Byron and Shelley, but also by the writings of more contemporary writers like

Rabindranith Tagore from India, who inspired generations of Chinese students and influenced much of modern Chinese; Chinese language had changed forever.

Following the Japanese invasion, the focus of Chinese cultural activity changed again. From 1937 to 1946, it reflected the Anti-Japanese War. From 1946-1949, it reflected the civil war. In 1949, the Communists won the mainland, while the Nationalists moved to Taiwan. The Korean War right after this move helped to establish the rule of Mao in China, thus cutting off connections between China and most Western countries. Meanwhile, China joined the Socialist brotherhood of countries, but gradually broke away from them country by country. Many Chinese artists studied in the art schools of these Socialist East European countries, [3] and their arts became a leading influence in the Chinese art of that time. The realistic, sometimes naturalistic, style of the nineteenth-century Royal Academy of old Russia was incorporated into the Socialist-Realist style, which became the chosen style for socialist propaganda in all the Soviet countries, and also in China. The themes of the artworks were required to represent either the working people or a historical event that contained patriotic meaning. Such themes and styles were the only ones that were allowed in the art curriculum in schools. The traditional Chinese art of the scholars, the *wenren*, was considered to advocate Feudalism and was therefore forbidden. Even folk art was considered to be superstitious and backward. When the Art Institute of Beijing, today's Central Academy of Fine Arts was built, traditional Chinese ink painting was not even in the syllabus. Not until much later did the founder of this academy, Xu Beihong, a French-trained master who devoted his style to Neo-Classicism, set up the Department of Color and Ink, which finally was turned into the Department of Traditional Chinese Painting. The realistic French or Russian styles of oil on canvas, which was never a traditional medium in China, became dominant even during the total isolation and violent uprisings against Western political thought. Today's American audience may well be aware that China had closed itself off during this period and had no connection with the Western world. But perhaps they do not know that in that society, everything except paintings and sculptures were in the style and format of the West. The best example of this contradiction is the image of Mao hanging above Tiananmen Square as a symbol of the People's Republic of China, which is a Western-style portrait.

In 1951, the Chinese government organized the Association of Arts and Letters that supported most of the professionals working in the fields of fine arts and literature, but it gradually eroded their freedom of expression. In 1966, the onset of the so-called Cultural Revolution cut off all international connections for Chinese individuals. This revolution developed far beyond anybody's expectations and exercised total control over China for the next ten years. No one knows how much has been destroyed—how many cultural relics, texts, paintings, buildings created over thousands of years, disappeared forever. Universities were closed and schools offered no classes. Libraries were blocked while Mao's books were the only

publication allowed. Under such an "educational" system, a whole generation grew up in ignorance. Despite all this, the basic love and respect towards knowledge and cultural tradition did not die. In 1976, Mao died. A group of Fascists known as "The Gang of Four" were jailed and tried in October 1976. China got her second chance. At this moment in history, modernization became a new issue. Modern art and Western art of the modern period was brought to the table for discussion.

Instead of following the historical order and occasion, Western books that had been published and translated over many years appeared all at once on the bookshelves together, along with ancient Chinese classics. Everything from Plato to cooking-menus of the Qing dynasty, biographies of Karl Marx to the novels by D. H. Lawrence, Pascal to Milan Kundera, were discovered all together by the Chinese readers. It did not matter what the sequence of thought was, what the sequence of theories and their relationships were; whatever was Western, translated, and printed or reprinted and was for sale, was available and was very popular. As Xu Bing says in his interview, people of that time "would read anything that was offered like a hungry person." Chinese youth were hungrily absorbing and digesting the world after a long period of barrenness and starvation. This was a new era which some people call the "Chinese Renaissance".

Besides political changes and economic recovery, other phenomenal changes came about during the late 1970's and early 1980's: Picasso and Dali in the visual arts, Kafka, Zweig, and Camus in literature, Yeats, Eliot, and Baudelaire in poetry, Freud, Nietzsche, and the New Left Marxism in philosophy. This is quite similar to what happened in the West during its Modern period. However, in China, it happened altogether and at once in the late 70's and early 80's. Some young Chinese were obsessed with individual western artists for a period of time; some would read or imitate whatever those artists had said or done. At the same time, traditional ink art and its techniques and meaning never lost ground.

Even though the Cultural Revolution came to pass, all publications and open discussions were still under the observation of governmental authority in China. This cut back on access to further Western thought. Decisions about censorship fluctuated arbitrarily from week to week. It was impossible to predict who and what could be mentioned and when. Luckily, artists moved fast. Some would experiment with five or ten different styles from Renaissance to Dali, or from Monet to Picasso, or other Moderns in a single year. In the early 1980's, Rauschenberg was permitted to have a show at the National Art Gallery in Beijing. His work shocked the Chinese art world and its impact was long lasting, and challenged many young artists' conception of art.

In less than eight years, Chinese artists experienced no less than one hundred years of the development of the intellectual history in Europe, and were ready to establish their own cultural milieu. Among

China. This work was composed of invented Chinese-script-like characters which he had worked on for four years. They were carved individually on wooden pieces like the ancient printing seals. Such seals contained only one word on each wooden piece, which gave the printer the freedom to reuse the same seal in new arrangements when composing other texts. Compared to the earlier printing blocks that were carved with the entire page on one large block and could be used only for that document (the earliest copy preserved today is from the 7th century), this new technology speeded up the printing process. A commoner named Bi Sheng invented this moveable type in the Northern Song dynasty in 1040-1048 CE, about 400 years before Gutenberg invented the printing machine to make widespread use of moveable type. Inspired by Bi Sheng, Xu carved calligraphic words and printed them in the Northern Song dynasty style, but not even one word was decipherable, despite the fact that the writing looked like Chinese. Instead of binding the prints in book form, he displayed them on walls and hung them from the ceiling. This form of "fine art", both confused and excited the audience, but the authorities were angry. In 1987, Gu and Xu, the two celebrated artists, left China to see the world. They expected to continue as creative artists, though their future in this new world was unknown.

In the late 1980's and 1990's, especially until the 21st century began, the nature of Chinese art had been changing. The slow decline of Socialist ideology, combined with the economic boom, brought about a comparatively more open society aided by technology. Ironically, this has also led to a lack of appreciation for traditional art among the youth, especially after 1989. If we examine contemporary artists in China today, we see the influence of Gu and Xu, especially in the methods and the mediums they use. However, the works of these four artists in the United States appear alien to Chinese audience, since their works gradually began focusing on issues related to their lives outside China. Their early education and experience in China belong to a past that the younger artists have not experienced, thus making it harder for them to understand some of the content and context of the art, while the older audiences that do understand the content and context are not able to appreciate their so-called contemporary methods and mediums. In effect, these artists are labeled as New York artists in China, whereas in the United States and the West, they are labeled as contemporary Chinese artists even though they have lived the majority of their artistic lives in the United States.

It appears that the nature of contemporary art in China is a combination of the Western sense of Modernism and Contemporary art. But they were based on different foundations: the Chinese classical traditions cooperated with the neo-classic school in Europe and the socialist-realist concepts of the former Soviet countries, although they differed esthetically and stylistically from each other. When our four artists left China, they grew out of their original roles as path breakers; instead they harnessed their courage to launch themselves as contemporary artists within the American milieu, while they continued to search for new approaches and new mediums to express their true emotions.

The Art of the Intellectuals: Four Chinese and Artists Abroad
When we examine the works of Gu, Wang, Xu and Zhang, it appears that they share two main characteristics. The first, inspiration, came from the ancient civilization of China, such as stone steles, woodprints, bookbinding, and papermaking. The second, their purpose, was to reinvent the favorite art forms and themes of traditional Chinese art: calligraphy, ink drawing, and sculpture; *shanshui* landscape, Buddhism, and folklore. While viewing their works, one senses the heavy hand of tradition that has lasted for thousands of years with a deep sensitivity to humanity, while also sensing their light-hearted playfulness while recreating it. Xu Bing spelled out:

I am willing to wait for many years to make a joke.[4]

What is the joke indeed? I do think this question is crucial in understanding the art of these four men from China, and also of all immigrants from many ancient civilizations and how they contribute to America. Once they leave their home country behind, they have a different perspective of themselves and of the many orthodoxies they had tried to rebel against while in the home country, and are able to reinvent themselves and their tradition in a light-hearted way without the burden of having to strictly conform to it.

According to an ancient legend, a man named Cang Jie invented the Chinese written language. When the written characters were being created, the sky dropped millet and demons howled the whole night long. What depressed the deities was that from that moment, humans could communicate among themselves thus decreasing the power of those super natural beings. This story tells the Chinese attitude towards written languages.

The earliest written documents found today are from the Shang dynasty (1600-1046 BCE) in Anyang, the center of the second dynastic period of China. These documents consist of words inscribed on the oracle bones made from turtle plastrums and animal bones. These bones were used to communicate with gods during divination. Only royal ritual practitioners were permitted to inscribe these words, and only they could read and convey the answer from the gods. Such a religious purpose made reading and writing sacred, and gave power to those who are learned in written languages.

Since the Western Zhou dynasty (1046 BCE-770 BCE), the court began to select writers and scholars and make them royal officers. Their jobs included collecting folk songs and many of them are recorded in *Shijing*, or the Book of Poetry. During the Eastern Zhou period (770-221 BCE), Chinese intellectuals enjoyed great freedom of thought and speech. Many philosophical schools developed and much of their thought from that time remains. The most important schools are Confucianism and Daoism/Taoism. Confucianism emphasizes moral code and ritual behavior. It provides an ideal of

Figure 4
Landscape near Xi'an

Figure 5
Mines for the stone materials of Gu
Wenda's steles, near Xi'an

Figure 6
Craft worker carving inscriptions
on the stele for Gu Wenda

building a perfect society and of reaching the highest and noblest quality of mankind. Daoism searches for harmony between human beings and nature. When such a harmony is achieved, human beings and nature will join as one.

These two philosophies of Confucianism and Daoism became the major foundations of Chinese civilization. Historically, the route to respect and honor in Chinese society was through one's ability to read and write well, which included one's ability to do calligraphy. However, words could be dangerous too, for one's writings could determine one's life—one wrong word could cause disaster to many lives. Throughout Chinese history, we read about the persecution of scholars, and how words were effectively used against them. During the Cultural Revolution (1966-1976), *Da zi bao*, or political posters written in extra-large characters were posted on the walls with made-up accusations and nonsense, vilifying and attacking those who were considered the "enemy of the people". Those *da zi bao* were brutal and could be fatal for the person concerned. They were posted in all possible public locations in China. Gu and Xu took the format of *Da zi bao* and filled it up with Chinese-like script that purposely made no

sense, thus making a powerful statement about the so-called Cultural Revolution itself.

In Gu's work *Retranslating and Rewriting Tang Poetry*, he took an ancient art form stone stele used for memorials, and carved them with Tang dynasty poems and their English translations. However, such a translation was not based on their original meanings but their Chinese pronunciations. The translation therefore has nothing to do with the original content but is changed into a totally new poem. This new poem is translated once again into Chinese, not based on its English meaning but its English pronunciation, which does not make sense to anybody. This new version is what Gu uses to carve in Classical calligraphic style into the center of the stele, while the original Tang poem is incised on the right corner, and the new English poem is on the left corner in a much smaller size of printing-style calligraphy. Gu invented a system for his translation according to its pronunciation. It is a difficult game, isn't it? It is a difficult joke too, and requires considerable thought on the part of the artist and the viewer. The material of stone for Gu's steles came from the mountains in a suburb of Xi'an, Shaanxi province, near the ancient

Figure 7
Gu Wenda, A stone stele during its
carving

Figure 8
Crafts workers tapping the inscriptions
on stele

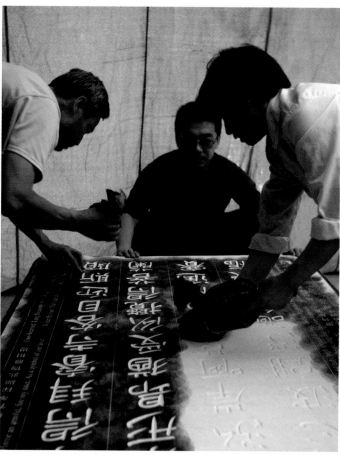

city Chang'an, the capitals of the Han and the Tang dynasties and the starting point of the Silk Road. Gu located experienced stone-craft workers and hired them to use traditional techniques for mining the rocks, forming steles, carving the inscriptions, and making the ink rubbings on paper upon the finished stone carvings. The inscriptions are based on Gu's own calligraphy which displays his skill in brushwork and his knowledge of writing styles.

Stone stele, *bei*, is not new to the Chinese people. A stele usually contains inscribed essays about an important event, a tribute if it was placed in front of a tomb, or documents of national treaties, or even poems. It can state historical facts or private records and is carved in stone in order to be kept forever. Ancient calligraphic stone carvings are still found on top of the Mountain Tai, at Shandong province on the east coast, which were carved long before the stele developed into its current form in the Western Han dynasty. Mt. Tai represents China herself, and is the most sacred mountain to the Chinese people since the time of the Qin Dynasty (221-206 BCE). When the First Emperor of the Qin Dynasty, Qin Shi Huang Di visited this mountain to meet God, he claimed that God had granted him the

authority to rule China for millions of generations. To memorialize this event, he ordered craft workers to carve an essay on a huge piece of rock in the mountain with a magnificent calligraphic style. The characters can still be viewed today despite thousands of years of exposure to natural forces. Even though the power of God did not prevent the death of the First Emperor that happened shortly after the visit, or the ending of his one-generation-long dynasty three years later, this piece of rock has survived through time and has become one of the most impressive steles and a valuable example of the Qin writing style. There was no other emperor who dared to visit Mt. Tai again for the next two thousand years, but an empress of the Tang dynasty, Wu Zetian (9th century), or Queen Wu, came to this mountain and "met" God. Queen Wu did not call herself empress or queen, but used the male term "emperor". She wrought many changes in society, including encouraging women to get education and allowed women to be officers of high rank. She treated people of all races and origins equally and allowed foreigners to do business in China or to hold a position in her court. She supported Buddhism and commissioned the largest cave in the Longmen Grotto to carry on the practice and development of Mahayana Buddhism; under

her rule, Chang'an was one of the most international, prosperous, and largest cities in the world. She enjoyed liberty in sexual activity and lived in luxury in a style that upset later Confucian practitioners. According to historical records, she killed many enemies including four of her own five children, one of whom had been her favorite daughter but was beaten to death while she was pregnant, all in order to keep her power. In her will, she ordered her stele to remain blank, in contrast to all former emperors and celebrities and even commoners. In front of her mountain-like mausoleum larger than that of most male emperors, there still stands a huge stone stele, taller than most of its kind with not even one word on it. "Let history criticize me", she seems to say, with great confidence. Indeed, who bothers to read inscriptions of the achievements of each "important" figure, describing what they may or may not have actually done? Her empty stele is much more powerful than all the ones that are filled with a tribute. Sometimes silence is more powerful than words.

What's the meaning of words then? Words may be false, words can be misleading, and words may indeed be meaningless. Who can truly understand the original meaning of a poem after it is translated into another language? How do you know the texts you are reading and reviewing are the truth and not a guide through your misapprehension? When the First Emperor of China recorded his contact with God in a stone carving on top of Mt. Tai claiming God had given him the right to be emperor for eternity but died right after it, what do those words mean? It certainly meant a lot to Chinese calligraphers since they kept copying the calligraphy for two thousand years, but what is the relationship between the words and the truth?

In the United States, Xu Bing continued to develop his "square words" project of non-readable false Chinese written characters into a legible Western word that looks like it is written in Chinese script. For example, "A" turns into 人, and "O" turns into 口. He rearranges the Western alphabet into the structure of Chinese written characters, thus creating another contradiction; Chinese audiences may think it is Korean or Japanese, while English speakers, who would initially assume it to be Chinese on account of its visual characters, would turn out to be the ones who could actually read it. Xu Bing thus began to bring actual words into his ink paintings. First, he used words to replace images. He took the Chinese written character such as 木 for "wood," to replace the image of a tree; used the character 川 for "flow" to represent a river; used the Chinese word 石 for "stone" to represent a rock, or many such "rocks" to represent a mountain. Since Chinese written characters are founded on visual models, each word is a picture. Each picture represents the visual appeal of that matter, even an abstract one. Xu Bing introduces us to a new way of thinking by using Chinese script (image-words) to compose a landscape painting rather than the images themselves, and therefore, the painting can be "read" as well as "seen." These words are easy to recognize even by non-Chinese readers due to the nature of their visual character. In addition, Xu's composition and arrangement of words parallel to ancient Chinese *shanshui/*

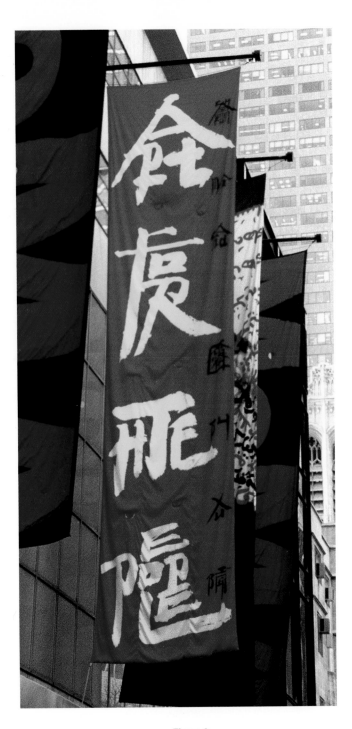

Figure 9
Xu Bing, Art for the People, fabric banner, dye sublimation on dacron polyester, 9 x 36 feet, displayed at the Museum of Modern Art in New York, 1999

landscape painting give his audiences an illusion of looking at an ancient Chinese ink *shanshui* painting.

The works of Zhang Hongtu, like Xu Bing's, work on many levels. At first glance, these paintings are oil on canvas, but with a traditional Chinese *wenren's shanshui* composition. When you look at them, you will no doubt recognize them as copies of famous landscape paintings of ancient China, and even if you are not familiar with the originals, you will still recognize them as "Chinese" paintings. You will also recognize the brushworks as Western, and if you are a little more conversant with Western art, you will recognize them as the brushworks of Van Gogh, Cézanne, and Monet. Thus both Chinese and Western viewers, irrespective of whether they have seen the original Chinese paintings or the original Impressionist ones, recognize the presence of both kinds of art. What's going on? Why does this artist choose to entwine the medium and the brushworks from different cultures and times?

Zhang Hongtu's work brings up an interesting topic for discussion, for there is no concept of landscape painting in traditional Chinese art, but of *shanshui*, mountains and water. *Shanshui* is not landscape, but mountains and water, which both contain spiritual value and therefore are not mere mountains and water, but idealized nature as perceived by the human heart. The paintings represent not only a lyrical presentation of nature in a visual sense, but are also a tool to present space, distance, myth, philosophies, and a certain belief in nature that is associated with the longed-for perfection of human beings. Chinese artists and viewers are no mere viewers looking at nature, but become one with nature, transformed into a part of nature within the mountains and waters recreated in the painting. Viewers are expected to look at these paintings and become part of the paintings. In other words, there is no viewer but only a participator in front of a Chinese *shanshui* who actually takes a journey in and through the painting, which is very different from the Western concept of viewing a painting. Zhang Hongtu emphasizes the difference between landscape and *shanshui*: one is a screen with mountains, water, and trees; the other uses this screen as a medium to represent harmony between nature and humans. The difference in the purpose and uses of nature contain fundamental differences in cultures in *shanshui* and landscape paintings.

When Zhang imagines an Impressionist making Chinese *shanshui*, he constantly twists the two cultures together and yet is within neither one. Seeing Chinese painting through a totally different perspective leads him to hide himself, and yet be honest to his conception. The ancient Chinese artists were not copying the landscape but the idyllic view of nature from their hearts, after much reflection and long after their actual encounter with the landscape, while the Impressionists represented nature in its physical existence and worked mostly outdoors, right in front of the landscape they were painting. Zhang's work challenges both philosophies and traditions, and thus leading us to rethink history and art history, questioning the experience of our eyes.

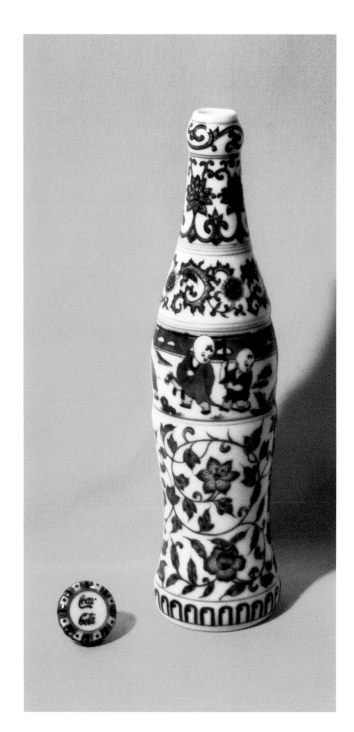

Figure 10
Zhang Hongtu, Kekou Kele-Coco Cola,
9.75 x 2.85 inches, porcelain, 2002

Figure 11
Wang Mansehng, Study of Gong Xian
(Thoughts about Gong Xian's Paintngs),
ink on paper, 2003

Wang Mansheng, while seemingly following the traditional philosophy of the *wenren* and traditional Chinese painting, also questions the dynamic between the different cultures he lives with. He differs from all the academically-trained artists in that he taught himself to paint in traditional Chinese ink and brush. He is searching for a level of excellence in brush and ink work to present his personal feelings towards life, history, and nature. His passion towards the lotus and classical poetry inspired him to create his own style of lotus painting in ink and color, shown in this exhibition.

As a scholar in Chinese classics, Wang Mansheng is much more exposed to the world outside China than the traditional *wenren*, and thus sees the Chinese classics with a fresh perspective, and as an artist, he aims to pay tribute to this tradition. In contrast to many professionally trained artists from China who changed their professions when they immigrated to the new world, Wang Mansheng started a new career as an artist after he came to the United States. His beautiful dreams of China were transformed into ink and color, into the lotus and water lilies in a pond under the moonlight, into the lotus leaves and petals blowing in the gentle wind, by the bugs and flowers drunken in deep summer. His experience as a TV director helped him see the composition of his paintings through the eyes of a viewer. You can see panning, detailed shots, and long shots; there are many different angles that reflect camera-like compositions, and different speeds of shooting to create different emotions and atmospheres. The compositions of

his paintings are not traditional, neither the brushworks nor layers of colors that are dabbed on. His lotus paintings are not traditional "flower paintings" as catalogued in Chinese art history. They are remarkable and unique creations by a Chinese-born New Yorker, who learns something new each day and communicates with American audiences through a Chinese brush pen.

Wang Mansheng also brings his series of prints described as a *Study of Buddhist Figures*. He noted the inscriptions on the sculptures during his visit to a Buddhist cave in Shanxi, and wondered about the reasons for the differences in their messages. As Wang Mansheng explains:

Different images were created for different purposes. Patrons supporting the creators of the statues had prayers inscribed on their base—for parents who had passed away, for themselves and their families—entreaties for a peaceful life, good fortune, the removal of hardships, protection from disaster, and rebirth in the Buddhist Paradise. A patron could be an individual, a family, or a village. The imperial court, the aristocracy, and the high officials paid for the best quality.[5]

During this trip to Shanxi province, Wang Mansheng was saddened by seeing how people in China today have no appreciation of their artistic heritage or the few remaining pieces of art. These Tang dynasty (618-907) sculptures and reliefs carved into the cliffs

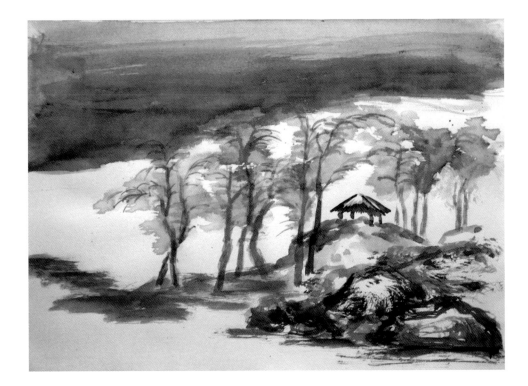

Figure 12
Wang Mansheng, Study of Gong Xian,
8.5 x 11.5 inches, Ink on paper, 2003

were trashed by the local people for cracking lime. "In an instant, a creation existing for a thousand years or more can be destroyed or vanish."[6] Inspired and touched by these sculptures and reliefs, Wang created this series of works. He experimented with a new medium: print. Also thousands of Buddhas in a Mandala, one single Buddha carved in the Northern Wei style (3rd-6th century), and an essay written by himself in elegant calligraphy. Buddhism touches a great many regardless of race or culture, for love, mercy, forgiveness, and wisdom speak to all humanity. Buddhism does not allow a supernatural being to judge each individual, but lets each being live in his/her own goodness. Buddhism treats intelligence and mercy as one,[7] while such a mercy has nothing to do with charity. Mercy and love come from within each individual when they have equal empathy for all, but instead of thinking that everybody was born in equality or that they share equal rights, Buddhists look at all with an equal understanding. Buddhism emphasizes an overall comprehension of knowledge and the personal impact of such an understanding; it also recognizes the intelligence of each individual being. In this way, one does not think one could be better or higher than others, for enlightenment is in one's own hands rather than in another's selection or compassion.

However, the purpose of Wang's project is not to express Buddhism, but to express how Buddhism, like all religions, has served as a tool for the powerful while also serving as a hope for the common people. Queen Wu of the Tang dynasty (9th century), whom we discussed earlier, patronized the largest cave at the Longmen Grottos. The Queen's generosity in supporting Buddhism was more as a means of gaining power for herself than as a way of propagating Buddhism. Queen Wu's dictatorship proves that she had no consideration for the poor, for salvation of all beings, and not even for her own *karma*. All the same, religion is the best tool and the twin of many rulers.

As Wang Mansheng points out, people who practiced Buddhism and patronized these caves, sculptures, or Buddhist steles all held different purposes and wishes. Some are true believers and practitioners. These people live through love, giving, and never stop studying and improving themselves, with no thought of benefit or return for their good deed; some practice it as a habit or for a good name without much understanding of the philosophy; some practice it as a lifesaver while their behavior has nothing to do with Buddhist principles; and some use it as a tool for ignoble goals.

Such a statement gives this study a complexity of meaning that looks beyond these images of Buddhas. It leads us back to the question that the other three artists' works in our exhibition also lead to: What is it? Where are we standing now and who are we? There is nothing in this world that is as simple as it appears. Truth is usually hidden, reversed, painted, forgotten, or forged. To discover the truth of life, Gu, Wang, Xu, and Zhang retreat to an ancient civilization to absorb its power. Power means the good of humanity

and it comes from understanding and forgiveness, but not force, and that is civilization. All four of our artists would agree.

Ancient Chinese artists discovered that the spirit travels beyond the material world and good artworks appeal to this spirit. These Chinese-born artists practice these ancient philosophies while their art breaks through all forms of boundaries and limitations, both Chinese and Western. Their works no more belong to China or to America. No matter what country one comes from, and what idea one holds about China or America, these Chinese-American artists make one comprehend a sense of history and identity that goes beyond just the visual comprehension of our eyes.

These four artists, by juxtaposing the old and the new (whether it be cultures, traditions, or nations) give us a fresh insight about both and also make us chuckle at the playful way they present it. Much of this laughter may or may not come from cheerfulness, but certainly comes out of their stimulating our thoughts. By sharing their own thoughts and the beauty of their art, they teach us to laugh. Have a good laugh and think again.

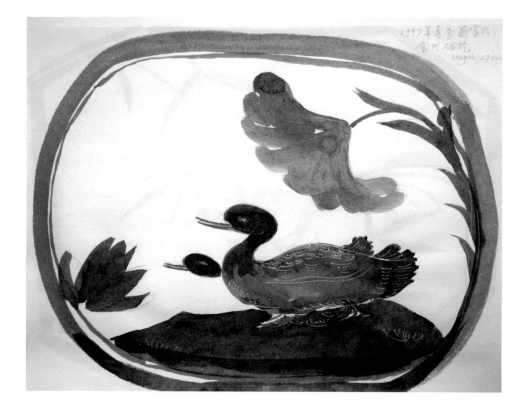

Figure 13
Wang Mansheng, Study of Cizhou Ware, 14 x 11 inches, ink on paper, 2001

14

A Home of Hair: Abjection and Wenda Gu's *china monument: temple of heaven*

Regan Golden-McNerney
Department of Studio Arts
University of Wisconsin-milwaukee

In the piece, *china monument: temple of heaven* from 1998, Wenda Gu builds a home for the self in a global era out of hair and language. *china monument: temple of heaven* is one part of the on-going *united nations series* for which Gu has created twenty monumental works of art from human hair. The hair, based on the location of the monument, may be woven into curtains, cast into bricks, or distilled into ink, requiring participation from up to forty barbershops over a four-month period. [8] For Gu's *china monument: temple of heaven*, the hair was collected in Gu's two respective homes, the United States and China. The towering sheets of woven hair in the *china monument: temple of heaven* filter the bright lights of the gallery, creating a canopy over a solid wood table at the center of the installation. The curtains of hair act as both walls and windows by demarcating a defined space; yet, enabling the viewer to look through them. The curtains also reference Chinese scrolls, as each panel is embedded with Gu's own uniquely formed vocabulary. From a distance the panels look like enormous sheets of paper with ink lettering, but up close each curtain consists of individual strands of hair. Although the hair is elegantly suspended in soft panels, it is also a repulsive form of human waste detached from the body and for this reason the hair could be labeled "abject." In the *china monument: temple of heaven*, Gu utilizes abjection to situate the viewer in a liminal space. The simultaneously alluring and repellant quality of the hair makes it the ideal medium for Wenda Gu's exploration of the complex relationship between the sense of self and the sense of place in a global community. Through his use of hair, Gu is able to reconstruct the definitions of the self and the global home by relocating the subject, expanding the collective narrative and transforming modes of signification. Wenda Gu creates this new definition of the self by celebrating the abject or the in-between; between subject and object, between literacy and illiteracy, between place and space. With the dissolution of these dualities, the boundaries of the self and place become permeable.

In the *china monument: temple of heaven*, similar to other works in the *united nations series*, the body is referenced through the use of hair transformed into the walls, bricks, carpets, and ceilings that define the installation space. The hair may inspire in the viewer a sense of connectedness to a broader community through the recognition of the familiar and shared aspects of the human body. At the same time, the hair may also cause the viewers to be repulsed by the breakdown of their own bodily boundaries. Wenda Gu

describes the viewer's response to his hairy installations: "the overall reactions to this work range from severe 'repulsion' and 'disgust' to puzzling queries, then ultimate recognition—it is us." [9] Through this process, Gu's curtains of hair in the *china monument: temple of heaven* disrupt the viewer's sense of their own bodily boundaries upon entering the installation. The effect of the bodily materials in the installation provokes a discussion of Gu's work in relationship to Julia Kristeva's theory of abjection. Art theorists, when discussing other contemporary artists whose work references the body, such as Kiki Smith and Mike Kelley, have utilized Kristeva's theory of abjection developed in her book *Powers of Horror* from 1980. [10] Kristeva, working with a form of non-Freudian psychoanalysis, argues that hair may be defined as abject because it consists of dead cells outside the traditional boundaries of the body, similar to blood or nails; yet, these substances are also formed within the body. Kristeva defines abject as "something rejected from which one does not part." [11] The abject is between subject and object, hence rupturing the traditional boundaries of the body. Kristeva's description of abjection relates to Gu's discussion of his hairy art works as between subject and object. As Gu explains, "They [the works] are the antithesis of the art as objects...they are as real as the people who look at them." [12] The bodily materials in Gu's work make it abject in that it cannot be categorized as either object or subject. Gu did use abject bodily materials in his early works *placenta jars*, 1990 and the *oedipus refound #2: the enigma of birth*, 1993; yet, the object-like scale of these works does not present the same type of challenge to the subjectivity of the viewer as the *china monument*. The towering hair screens created for the *china monument: temple of heaven* installation exploit the unsettling nature of abjection, as a bodily substance that is both repellant and alluring, to disrupt an individual's sense of identity through dislocation of the bodily boundaries.

Wenda Gu's art works and Julia Kristeva's theories suggest the potential in "primal" or abject substances for breaking down the boundaries of the body and the self. Kristeva argues that the abject challenges the Freudian limits of the body by referencing the pre-Oedipal point before the individual is constructed through language as subject or object. [13] According to Kristeva, "primal" and abject substances like hair and blood symbolize a time when the individual and the mother were inseparable. In this stage of development, the boundaries of the subject are not clearly defined, since the child has not yet constructed the mother as object and "Other" through

language.[14] This aspect of Kristeva's theory of abjection is particularly relevant to Gu's work, since he describes his artistic focus as "the human body and its primal substance."[15] Both the use of hair as a medium, and the weaving of language into the hair walls, creates a place for the "primal" self before the formation of the self as subject through language. The "primal" substance or abject substance also suggests a relationship between the human being and nature that was unified before construction of the self as subject and creation of the mother as object or "Other." This resonates with the use of hair in Gu's work as a representation of a landscape of rivers or veins.[16] The ability of abject substances like hair to reference the condition before the creation of the self as subject implies, according to Kristeva, that the artist's goal is to present the abject or the "primal substance" in order to challenge the subjecthood of the viewer:

In a world in which the Other has collapsed, the aesthetic task—a descent into the foundations of the symbolic construct— amounts to a retracing of the fragile limits of the speaking being, closest to its dawn, to the bottomless "primacy" constituted by primal regression. Through that experience, which is nevertheless managed by the Other, "subject" and "object" push each other away, confront each other, collapse, and start again—inseparable, contaminated, condemned, at the boundary of what is assimilable, thinkable: abject.[17]

Gu's use of abjection and hair in the *china monument: temple of heaven* results in the dislocation of the subject and the collapse of the "Other" establishing a new collective experience within the installation space: "the separation and opposition between the subject and object melts in the shared experience of the viewers."[18] The experience of viewing the "primal" substance of hair in the *china monument: temple of heaven* removes the subject from the methods of constructing individual identity through the boundaries of the body and the limits of language.

The dissolution of the culturally constructed subject through Wenda Gu's use of abject substances is furthered by his alteration of language. The text in Gu's *china monument: temple of heaven* also transforms the individual who reads the words into neither subject nor "Other," insider nor outsider. For instance, in Gu's installation for the *china monument: temple of heaven*, he has sewn into the hair walls four separate pseudo-languages derived from English, Arabic, Hindi and Chinese. The shapes and letters of each word appear from a distance as though they could be read; yet, up close the words are nonsensical. As Gu explains in an interview, "Chinese readers could interpret the concept of an unreadable language as the mythos of a lost history, while non-Chinese readers could interpret it as a misunderstanding of an "exotic" culture."[19] Similar to the hair curtains that appear from afar like sheets of paper, but break down into tiny strands close-up, the text in Gu's installations is also simultaneously recognizable and undecipherable positioning the viewer between literacy and illiteracy. In this respect, Gu's use of pseudo-language again resonates with Julia Kristeva's definition of abjection as "not a

lack of cleanliness or health, but that which disturbs identity, system, order."[20] Through Gu's invention of pseudo-languages, he disrupts conventional modes of communication and reveals how inadequate these pre-existing systems of language are in a multi-centered society. Gu's use of abjection in the form of hair and language moves the viewer into a space between powerful and powerless, where bodily borders become obscured and modes of communication are redefined.

The viewer's inability to read the pseudo-language braided into the hair walls disrupts individual narratives, as well as a nation's collective history. In the *china monument: temple of heaven*, Wenda Gu acknowledges through his inclusion of text the important role that language has played both in developing his own identity in a multi-centered world and in framing national identity throughout Chinese history. As artist Xu Bing described in a conversation with Gu and the art historian Jonathan Hay: the written language taught in school during the cultural revolution of Mao was constantly changing based on the rhetoric of the leadership.[21] Gu articulates a similar association between politics, language, and national identity:

Language is the power of mind and manipulation. Think only of propaganda. Groups use language to impose their ideas on you. You learn to be controlled through their propaganda. It's very political. That's why the dictator is not as comfortable with the language inherited from the old emperor. He wants to establish his own language, currency, and so on to affirm his authority.[22]

For the *china monument: temple of heaven*, Gu selected specific types of texts, such as the ancient Chinese seal script, only to render them unintelligible in order to both assert and criticize the connection of language and national identity. For example, Gu explains the ancient seal script is illegible to most contemporary Chinese and to most international viewers creating equality and, perhaps, unity among individual viewers from numerous cultures within the installation. Gu suggests that the limits of language must be transcended in order to communicate in a global era; as he explains, "the pseudo-languages help us to imagine a universe beyond language."[23] The hair and pseudo-language that form the central structure of Wenda Gu's *china monument: temple of heaven* also represent the conflict between the individual and the community in which translation and transmission of meaning is often convoluted.

Wenda Gu's installation makes the viewer aware that the individual narratives that construct our identities are performed through language; thus, for the individual living in several cultures in a global community such as Gu, one's identity is constantly being reconfigured. Julia Kristeva characterizes this state of being in the *Powers of Horror* when she argues that those who recognize abjection are self exiles, constantly attracted to and dejected from society, neither a part of nor separated from themselves or others. As she writes, "A deviser of territories, languages, works, the deject never stops demarcating his universe whose fluid confines—for they

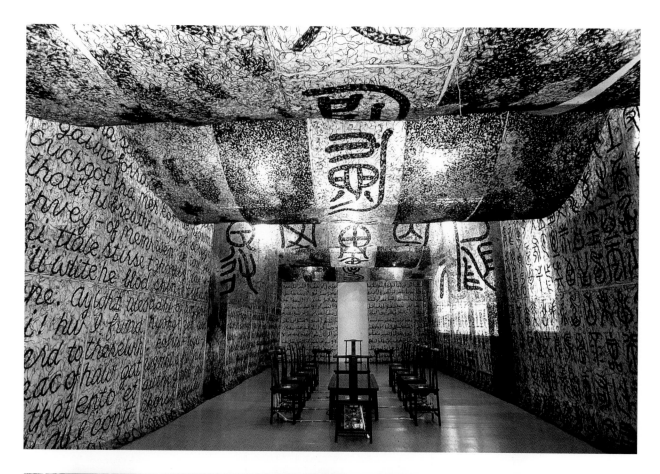

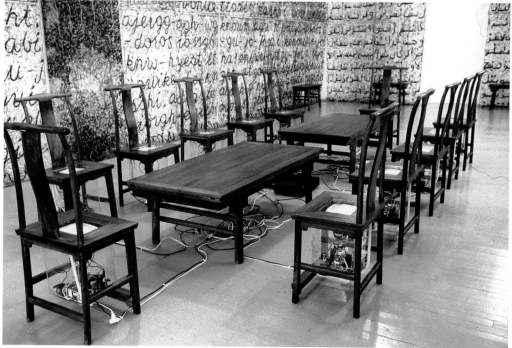

Figure 14a
Gu Wenda, china monument: temple of heaven, human hair, wood, and digital installations, 1998-2004

Figure 14b
Gu Wenda, china monument: temple of heaven, detail

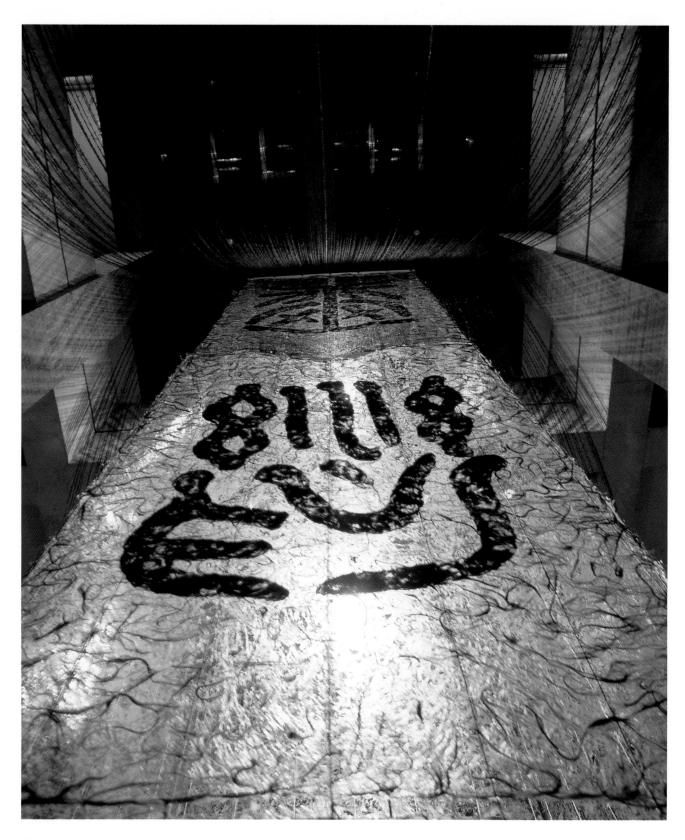

Figure 15
Gu Wenda, united nations series, detail,
1993-2004

18

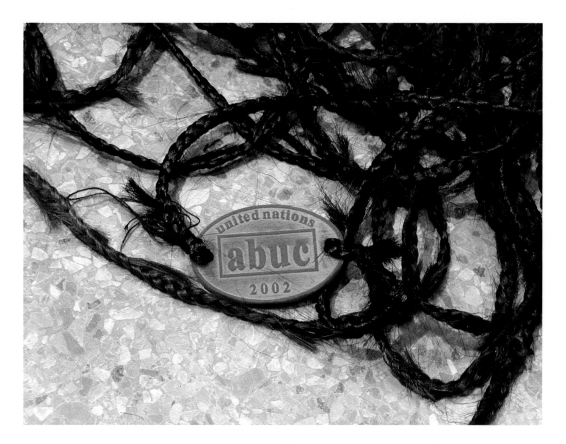

Figure 16
Gu Wenda, united nations series, detail,
1993-2004

are constituted by the non-object—the abject —constantly question his solidarity and impel him to start afresh."[24] Gu's role in the building of the *china monument* is complicated by Kristeva's theory, for he not only utilizes abjection in the piece, but he also acted in this dual role as both a cultural insider and outsider by installing the *china monument: temple of heaven* for the first time in the exhibition *Inside Out: New Chinese Art* at P.S.1 Contemporary Art Center in New York during 1998. Unlike the other pieces within the *united nations series*, in the creation of the *china monument: temple of heaven*, Gu did not consider himself an "outsider," making this an important installation in the discussion of individualism and place in his work. [25] Projected into Kristeva's role of the "deject," Gu is constantly rebuilding a home with abject walls in new nations until his vision of the *united nations series* is realized.

In the *china monument: temple of heaven*, Wenda Gu juxtaposes interior and exterior spaces in order to create a home for the self with and without boundaries. Gu installed the *china monument: temple of heaven*, beneath the ceiling of hair inscribed with illegible text, a table with twelve chairs fashioned in the Ming dynasty style. Gu's table and chairs suggest the potential to transform the space into a meeting place or even a home; the table and chairs suggest the local, while the text within the hair walls suggest the global. The solid table and chairs invite viewers to find a place for themselves, but the transparency of the hair walls convey a boundless space, thrusting the viewer into a space or place that is neither interior nor exterior. This quality of being neither inside nor outside, neither interior nor exterior also reflects Kristeva's definition of abjection exemplified by bodily substances like hair and nails, which are generated internally and manifest externally. Gu even makes the solid wooden chairs somewhat transparent by embedding in the chair's seat a video screen reflecting a vision of the sky and exposing the wires of the screen in clear cases under the chair's legs. The use of the sky imagery situated within the chairs references the unification of the earth and sky, of being both transcendent and grounded. This may be the model home for the new millennium--a retreat from the tumultuous world around us, but also a space/place from which to meditate on the complexities of our world. The transparency within

each aspect of the installation reaffirms Gu's articulation of the space as symbolic psychological territory for the poly-cultural, multi-centered self that inhabits several global homes with both fluidity and ambiguity.

The *china monument: temple of heaven* is a place/space to consider the existence of a global order, without abandoning personal memory and national identity. As critic Lucy Lippard defines place in a multi-centered world, "space defines landscape, where space combined with memory define place." [26] The memory of a nation's history and the memory of an individual's experience are both represented in Wenda Gu's monuments for the *united nations series*: the composition of each installation is determined by the historical events which define that country and the local people who donate the materials to build the monument. As Gu said, "I try to close the gap between the artwork and the audience by ensuring direct physical contact, interaction, and dialogue with the local population through the collection of the hair and reference to the cultural histories from which the monument will be created." [27] At the same time, the space/place that Gu creates of hair and language ask the viewer to examine the possibility of a new home. A space and place in which a nation's history is a building block, literally a block made of hair, in the transcendence towards a global order. The *china monument: temple of heaven* reveals Gu's definition of globalism, in which national history and personal history are building blocks for a world order as the boundaries of language, subjecthood, and the body are expanded to encompass the "Other." Gu suggests, by revealing the abjection inherent in hair and text, that a global culture, or a place for a new global culture to exist within, defies current methods of constructing the subject through limits of the body and language. Through his monumental work, the ultimate message of Wenda Gu's *china monument: temple of heaven* is to root one's self in a place, without establishing a fixed identity.

Gu Wenda's united nations series (1993-2004)

In 1993 Wenda Gu exhibited his first piece from the *united nations series* titled *united nations–poland monument: hospitalization history museum* at the History Museum and the Artists Museum in Lodz, Poland. Over the past ten years, Gu has constructed twenty monuments throughout the world in countries such as Israel, Japan, the United States, Sweden, and Italy. The design of each installation is based on an important social or political event in the history of that nation and the medium of each installation is hair collected from local barbershops for over four months. Depending on the location of the monument and the history of the nation, the hair may be spun, cast into bricks, distilled into ink and piled on the gallery floor. The most recent installation in the *united nations series* is *united 7561 kilometers* from 2003, which was exhibited at several locations, notably the Kansas City Art Institute and the Contemporary Art Museum at Bates College of Art. This latest installation is in many ways the culmination of earlier projects, because it includes hair from around the world that has been braided and labeled by nation, but laid out strand by strand the 7561 kilometers of hair would stretch around the world.

Gu Wenda's united nations–china monument: temple of heaven (1998-2004)

In 1998 Wenda Gu first exhibited the *china monument: temple of heaven* at P.S.1 Contemporary Art Center in New York. The installation is one of twenty monuments created in Gu's *united nations series*; yet, the design and the materials used make this a particularly innovative piece. Here, Gu grapples with the issues of identity and communication in bridging the two distinct cultures of China and the United States. The design of the piece is based on a Chinese temple as it is a place/space within which to meditate on both the advantages and perils of globalism. The space is created through curtains of hair, which act as both walls and windows defining the space and enable the viewer to look out into the gallery. In the hair curtains are woven several unintelligible pseudo-languages based on Chinese, English, Arabic and Hindi. At the center of the *china monument: temple of heaven* beneath a canopy of hair is a Ming dynasty style-table and chairs, embedded with screens projecting images of the sky. Every element of the work references a transcendence of boundaries both physical and psychological.

Artists in Their Own Words

Interviews by Wang Ying and Yan Sun

An Interview with Gu Wenda
Translated by Yan Sun

Can you talk about how the issues of race and diversity are relevant to your art?

The issues I am concerned with are probably different from general issues like the fusion of East and West. I want something that is more inclusive and can include all cultures. The immigrants all face similar situations. They continue their own cultural tradition, rebel against it, abandon it, and follow the Western culture, or try to mingle these two traditions. I was not satisfied with any of those solutions. To me, they were all stereotypical. It had puzzled me for a while. Then I came up with the *united nations series*. The project does not just include Western or Chinese cultures. It intends to include all countries and cultures, a truly international and universal project. Moreover, I also include the peoples from all over the world through the hair of more than one million people which is used in the creation of the work. The project has been ten years in the making and is still ongoing. It is rare in the history of art, as it is a Utopian idea. This work now seems very ironic, as the reality is that the world now is not united but more and more separated. The national flags from around the world when I first created the work in 1999 included the flags of all 188 countries. Last year there were already 191 countries. The reality contradicts with my Utopian idea.

You call your Utopian idea "Tianxia Datong". What is your Utopian idea? How different is it from Kang Youwei's ideas during the 19th century reform movement in China?

I am not familiar with Kang Youwei's idea. It is hard to say where my own Utopian idea comes from. It is just my natural inclination and ambition. Life is a constant struggle for artists who are not born in the United States. Western culture tends to label the artist before it tries to understand his or her art. I don't want to be labeled in any way because labels always come with pre-conceived ideas.

Recently, several scholars worked on a collection of critical writings on my art. In the book, they mention that some artists are international but they may not deal with international content in their art. In my case, my work is truly international. That's what I want to do. I don't necessarily want to become the kind of artist that the public wants me to be. It can become very stereotyped and tiresome. You must be wise enough to deal with all kinds of issues politically, socially and racially, though you may not always succeed. The social structure may not allow you to do so, as it always forces you into the position of being the translator of Chinese culture.

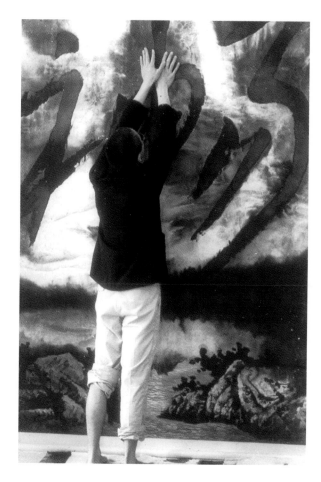

Figure 17
Wenda Gu, silent performance in Hangzhou

Because you are Chinese?

Yes. Some critics say my *united nations series* becomes a "cultural colonialist". My project in each country is based on local culture and history. I also use the hair of local people. Thus local history and culture are interpreted through the eyes of a Chinese-born artist.

If you use materials from local people and local history, it seems to us that you respect local culture very much. How does this fit into the accusation of "cultural colonialism"?

I agree with you. However, I also look at their local histories from a critical point of view, and with a Chinese point of view. For example, I used poppy flowers in my *united nations series* in Britain. The flower implies the Opium Wars. In the history textbooks in Great Britain and the United States, the Opium Wars are not mentioned. So it is not like I always praise the local history or culture. Rather I look at it from a Chinese perspective. When I exhibited in Italy, the Italians asked why such work does not come from the hands of an Italian artist since it uses local material and history. The comment in itself involves the issue of racial identity, but it was a spontaneous reaction.

The *united nations series* faced a huge challenge in Israel. There were protests at the Tel Aviv airport. The national newspaper also interviewed the curators, political activists and a writer to discuss whether or not my work should be done. Finally, I had a dialogue with the chair of the parliament on Israel's largest radio station.

What did you discuss with him?

The Israelis thought that as a foreigner I didn't have the sensibility of their tragic past and the meaning of hair in Jewish history. I explained to him that I fully understood the tragedy of the Jewish people during the Second World War. About 100,000 Jews arrived at Shanghai from Europe and then traveled to the United States. At that time, there was no other country willing to open its door to them. The most persuasive point I argued is that my project means to unite cultures and peoples. Without Jewish hair, my *united nations series* would be incomplete. There were negative and positive comments on the project. However, I convinced them. When I finished the project and left Israel, a customs officer at the airport even asked me if I needed his hair.

Why did you choose hair?

I believe that this millennium is a biological millennium. I am always fascinated with genetic research and biological engineering. These studies explore human body and may even lead to the extinction of the human race as we know it—they are exciting and dangerous and have the potential to be highly destructive. I want to bridge my own cultural background with this new millennium, and so I first created biological ink made of Chinese hair, and the paintings created with this kind of hair-ink are traditional in that they carry the actual genes

of the Chinese—it is of archival quality and also easy to collect . Hair lasts forever. When you see the Egyptian mummies, their hair is still intact after thousands of years. Hair is also associated with so many historical myths from different cultures. Thus, in my own way, I try to bridge tradition with the biological millennium.

You have worked on this material for more than a decade. What do you feel about this particular material when you handle it?

There is no special feeling involved when I use hair. I am looking at it from a very objective perspective. The material really allows me to connect past, present and future.

How did you conceive of the material for the Oedipus Project?

It was a process of thinking and experimenting. I made some large-scale installations of ink paintings by turning Chinese characters into abstract symbols in the early 80's. My first solo show of these works was at Xi'an in China, where there was a symposium on Chinese art history. The symposium chose the art works of two artists, Huang Qiuyuan and me. My exhibition was later pulled from the show because of the pseudo-seal script characters. My pick of pseudo-characters was really accidental. At the time, I was practicing seal scripts and I did not read them at all. I intuitively felt a great deal of freedom, for my idea is that if you understand the content of the characters, you will be confined by it. At the time, I was also intensively reading up on Wittgenstein's philosophy of language, and became interested in Wittgenstein's theory on the mystery of the universe that cannot be communicated through human language. I started to think about questions related to language and communication. In the second stage of the project, I abandoned the invented Chinese-like pseudo-abstract symbols as I lost faith in the power of language, real or invented. Although language is indeed second nature to human beings, it is still nature transformed through human activity, and is something set apart from our primordial, unmodified "first nature." Then, I did some experiments involving different kinds of materials, but I was not satisfied with that because there was no human involvement. For example, one work showed grass in different stages: living, dried and scorched, but I was not satisfied with that, so I gave it up. Nothing is more authentic than the human body, and hence my idea is to emphasize the human in art and also relate it to the biological millennium we are living in.

When did you have this idea?

Soon after I moved to the United States. My successful works in China were a series of large-scale ink paintings that were very well received by the critics in China. I am really grateful for my training in traditional Chinese painting, for because of that, I had a basis on which to build on. At the same time, I don't want to use exotic cultural elements just to cater to a Western audience.

The basic idea is that culture can't be translated. This will raise a question on the nature of multiculturalism

After a while, I was not satisfied with my experiments with materials and so I returned to the study of the human body. I read some studies on genetic research and am fascinated with it. I feel that the world of art is such a small world in comparison to that of biological engineering which has the power to inalterably change the future of humanity. These ideas and the several multiple issues associated with them led me to my *united nations series* through a complicated methodology.

Are you the first one to use pseudo-characters in Chinese art?

It is hard to say. I started using the pseudo-characters in China in early 1980's. I also did some installations and performances of large-scale ink paintings. One performance was executed by six of my students and me at the Zhejiang Fine Arts Academy. It was performed in a private setting rather than in the public. From 1984 to 1985, I made large-scale tapestry and exhibited at the International Biennial show at Lausanne in 1987.

For my graduation exhibition, I later learned that the school official had said that my work could not be published by the media. My exhibition at Xi'an was also closed by the local government. They thought that my pseudo-characters had political motivations. My teacher Lu Yanshao persuaded the school official to let me teach at the school after graduation. He thought that I was a "wild horse" and an exception, and I was permitted to follow my passion, but his other students had to follow the traditional path. I have already forgotten about many of my bad experiences in China, but then, every society confines you in its own way.

What is your confinement in the US?

It is hard to say. Every society has its limits. When I first came to the United States, I knew that I couldn't exceed my ethnic identity. I think my *united nations series* overcomes that, and that is my victory over this ethnic identification.

In an interview in 1987, you seemed to have clear thoughts on how to make Chinese art international. Do you see your goal as having changed since then? If yes, in what direction?

At that time, I was young, a romantic and an idealist. Because of that I was able to propose certain ideas. Now I am more mature. Each period has its advantages.

What about now?

Now I think I am more mature and able to meet the challenges posed by my ideas.

When did you start the idea of the Stone Forest and why? How did you expect a Western audience to understand it?

I can talk about this project for several days. Simply speaking, the work is a mirror of the multi-cultural environment that we live in today. The basic idea is that culture can't be translated. This will raise a question on the nature of multiculturalism. The project is more than 10 years-old now and is an ongoing one. It took me several years to locate the right stone source and the best carver. The design of the texts on the steles was decided after several changes. Finally, I choose a Tang poem as the starting point. I found an English translation, an academic sample from the 1930's or 1940's. It is basically the translation of the content, and had lost the beauty of the sound and the rhythm of the original. I then translated this English translation back into Chinese characters based on the sound. Ironically, I particularly choose the Chinese characters that would match the English pronunciation. Finally I created some new poems from selected Chinese characters. There are two aspects to this work. On the one hand, we realize that culture can't be translated; on the other hand, some entirely new ideas are generated from it under this challenge. From a traditional point view, writing a poem needs imagination and skillful control of language, but my translation did not need imagination. It resulted in creating a new poem just through my method. There is a certain sense of humor in it and can be read by both Chinese and English speaking people. Chinese can compare the original Tang poem with the one I created based on the sound. A native English speaker can read the English translation

and the new poem. I particularly use the popular Tang poems, as Tang poetry is originally a form of intellectual art. When every student can recite them, they already become pop art. I re-intellectualize pop art through my translations. All the calligraphies are created and written by myself. The new characters are formed by moving around, omitting, or recombining the radicals of Chinese characters. Everything is handmade including the carvings and even the stones are cut by hand from a quarry. I have a whole team in Xi'an to execute the work. I prohibited any use of explosives at the quarry so there will be no cracks inside the stone, which might cost future damage. The work is labor-intensive and energy-consuming. I invited specialists, art historians and professors in the Xi'an area to be my consultants. I cannot do everything myself, and needed a group of experts to execute my idea. My next project will use Shakespeare's poems, and the project will be similar to this one—just with a different starting point.

What is the reaction of the audiences to this work?
Everybody likes this work. The reaction is so different from my other exhibitions using sanitary pads and placenta powder.

What is the reaction of Chinese audience?
This work is not exhibited in China, though it has been published in China.

We feel the Chan (Zen) idea in your stone steles. Do you agree with that?
It is not exactly the case, for I have so many different experiences. I always say that my concept is synthetic. My psychological framework is like a cross—Marxist ideology and capitalist reality, on the one side, and Chineseness and internationalism on the other. All of these co-exist in me. Living in this country, my Chineseness is very obvious in my current life.

What were your initial impressions when you arrived at the United States?
There is a gap between reality and my ideal. My work still represents the idealism and is powered by it. Without ideals, there is no energy driving the work.

Do you think your art will be accepted in China?
Yes. The situation now is completely different from many years ago. Every country has their confinements. The only difference is that the confinements are established from different perspectives and in different scales. The arts of the avant-garde started in the West. The task of our generation is to let the Western art world know that we do have a well-established contemporary art in China.

What is your next project?
Many of my projects are ongoing projects. For example, my *united nations series* is an open structure that is constantly expanding with the addition of events happening around the world. I always say that I have two ages. One is my actual age, I am 48 years old this year; the other is my time in this country. It has been 16 years now. I am still learning. If I were still in China, by now, I might be enjoying an established tenure as an artist. Living in the United States, I am still a stranger to the culture in many ways, but as an artist, I am motivated to transcend it. That is also the exciting part.

A project I am working on now is called "Gu's simplified character." In Chinese you need two to four characters to make a phrase, but I am trying to combine two characters into one character to make a phrase. My idea is to create a dictionary of such synthetic words.

Interview with Wang Mansheng
Translated by Wang Ying

When did you begin to draw and why are lotuses a prominent subject of your paintings?

I began to paint when I was about ten years old. I grew up in a bad neighborhood in Taiyuan of the Shanxi province during the "Cultural Revolution". It was chaos and horror in society and a lot of crime happened in my area. The bad kids in my neighborhood always gave me trouble and beat me up. I was a quiet child and had only sisters. My first sister sometimes helped me fight back. But I had no interest in fighting or in hanging around with these boys. I liked to go to parks by myself. At that time all the gardens were ruined but once I saw a small lotus pond in one of the parks and the lotus flowers were in bloom. They were too far for me to reach so I sat and looked at them for a long time. During my next visit, I brought a pencil and a notebook and began to draw the flowers.

Did you begin drawing instinctively?

Yes, and later I read great many literary classics about lotuses. The poems about lotuses and the landscape of southern China formed beautiful pictures in my mind. The city I grew up in, Taiyuan, however, is in a mining region. Coal mines and the yellow soil make the earth barren and the only colors one sees are black and yellow. I had dreamed that someday I would go to south China to experience the beautiful land as the poems described. Meanwhile, Taiyuan is also a place rich with cultural traditions and history. For example, the place where my family lived was a three-sectioned courtyard complex. The architecture was very beautiful and the structures were unusual. The complex was three closed compounds with courtyards inside each, and connected with one another unevenly rather like those three-layered courtyards in Beijing. The roof lines were not strictly even. There was a big red gate to get into the first compound that was surrounded by thick stone walls and two stone lions were standing on each side of the gate. My courtyard was on the left side which was connected by an arched gate. You saw a stone screen in front of the door as soon as you walked in, and you had to go around the screen to reach the door. The compound was very calm. Some old ladies planted flowers in pots and kids would play around. The peaceful sunlight got into the yard in the morning. This complex may have once belonged to a big family but was occupied by many families of all kinds of people while I was growing up.

Figure 18
Mansheng Wang in His Studio, 2003

My parents did not get a chance to go to school. My father can recognize only a few words and it was difficult for him to even sign his name. He moved from Baoding in Hebei province to Taiyuan for jobs, so my family had no roots in that city; we had no relatives or old friends. My father worked in different jobs and had six children, all while he was already in his forties. My family lived in one dark room without a window but we had a skylight. I was born in that room the day we moved in. So my original name was Bansheng, which means "born during moving." I thought that name was silly and changed it in to Mansheng in middle school. But now when I think about it, I understand that the name says more about my origins.

I remember once when I was about two years old, I tore off a page with an illustration of a horse from my sister's text book. My father walked in when we were both crying loudly after the fight that ensued. My father glued the book for my sister first and then drew a horse on a stone board for me. I thought it was a wonderful painting. I loved to copy pictures and once I copied a tiger from a New-Year painting. My father loved it and mentioned it proudly for many years. My family had no money to buy a sketch book for me. My father worked in a leather tannery where there were many brown paper bags used for storing chemical powders. He brought those used bags home and we cleaned them up, cut the paper and bound them together as note books. That is the kind of note book I used through middle school. All my school work and all my paintings were done on these notebooks.

The state museum of Shanxi was not far from where I lived and had a great collection—the admission was free. The museum was modeled after two ancient buildings: the Temple of Confucians, and the Daoist temple of Chong Yang Gong. One is in a magnificent scale and

27

the other is in a delicate style. Inside the Daoist temple there was a garden with "scholars' stones," stones shaped like mountains and other natural shapes. The entire setting was very beautiful. All the rooms were full of collections but not with many visitors. Outside the museum was a dusty world in chaos and revolution; inside it was a peaceful land but no one was there. I went there numerous times and read all the descriptions of the collections.

What kinds of collections were they? Do you remember?
It was from the Neolithic period to the later dynasties: pottery, bronzes, stone sculptures and carvings, and lots of porcelain from the Ming and Qing dynasties' royal kilns. And many Buddhist sculptures from famous caves such as Tianlongshan and Yungang Grottos. All archaeological discoveries and random finds in Shanxi were sent to this state museum at Taiyuan. I think that my visits to that museum built a base for my later studies.

I had good teachers in literature and history since middle school. I loved poetry and pretended that I lived in a peaceful land. My lotus and landscape paintings all focused on this topic: peace. I admire the lifestyle of the ancient *wenren* artists and their paintings, such as Ni Yunlin. His world was full of peace. In fact, I read more Chinese classics in the US than when I was in China. I made a decision to paint full-time after I came to the US.

Why did you make such a decision, considering the fact that many full-time Chinese artists had to give up their careers as artists after they moved to the US and had to look for other jobs?
I see my painting career as a continuation of my career as a TV cameraman and director; both involve considerable work with visual composition.

Did you have teachers for your painting?
No, I never had a teacher but I learned from literature. My main interest in college was literature from before the Qin dynasty [221-206 BCE]. Ancient Chinese people treated literature, history, and philosophy as closely related. My BA thesis was about Fu Shan (1606-1684), an artist, philosopher, and a medical doctor of the early Qing Dynasty (1644-1911). He is from Taiyuan. There are many antiquities relating to him in Taiyuan. But my choice of him was not only because of the regional link but also because I admired him—he was a simple person, and never had the habit of showing off as

many *wenren* did. As a medical doctor he was not showy but took good care of his patients, and even refused to serve in court as a high officer. I studied his life, philosophy, and art, and I read a lot of literature. I created pictures from reading. For example, "*Jiangnan ke cailian/* one can pick up a lotus flower in the south of the Yangtze River…*lianyie he tiantian/* and watch the lotus leaves move around on the water…" "Tiantian" refers to the manner in which the leaves move in the water. It is so natural and so beautiful.

Is your brushwork for painting based on calligraphy?
Calligraphy contains principles and structures of both writing and of drawing. When you cannot paint well you can say that it is freeform, but when you cannot write well you cannot say it is freeform. Even the cursive-style calligraphic writing follows certain principles.

Did you have a teacher for calligraphy?
No. But I had many professors in college who were good calligraphers. Prof. Zhu Dongren, an expert in literary criticism, was one of the best calligraphers in the style of *xiaozhuan*, the Qin Dynasty seal script. He had a profound knowledge of literature, history, and cultures. I liked to chat with him and he taught me a lot that can't be learned in regular classes.

What's the difference between brushworks on painting and calligraphy?
I believe that brushwork on painting came from calligraphy, which I learned through my experience. Many subjects in Chinese painting came from literature. Much of the Qing dynasty artist Bada Shanren's work, which he claimed to have been inspired by the Tang and Song dynasty masterpieces were learned not from the actual paintings since the paintings were probably extinct by then, but he "sensed" the paintings from reading about them. Living in the "yellow earth" of Shanxi, southern China was a dream of paradise to me. The image of such a paradise came from literature. When I left the place of yellow dust and coals where no trees grow and came to a land full of golden flowers on greens, isn't it a paradise?

What was your first impression of southern China?
Beautiful!

Just like what you had read?
Well, during my first trip to college, I saw the lotus ponds as soon as my train crossed Shandong province. I grew up in the era of the Cultural Revolution when flowers were forbidden. I left home alone by train for the first time, and traveled to a strange place a thousand kilometers away, and it was a big thing. The world turned to green as soon as the train passed Shanxi, out off Niangzi Guan. When we crossed Xuzhou near the Huai and the Yantze Rivers' region, I was so excited to see miles of lotus ponds. The lotus flowers were red,

when you cannot paint well you can say that it is freeform, but when you cannot write well you cannot say it is freeform.

white, and pink, and I was surprised to see how beautiful they were. The train was fast, but the flowers were passing in front of my eyes again and again. I think that water is indeed the most wonderful thing. It is common but special. There is no life without water. I feel very comfortable whenever I see water. In southern China, there is a bright contrast between the green earth filled with paddy fields, and the golden yellow *youcai* flowers. In the south, people use the lotus efficiently—they eat lotus roots, seeds, the flower, and the pollen can be used for medicine. Whenever I had a school break, I would go to visit those southern cities such as Wuxi and the Lake Tai. The Yangtze River region is rich with culture and history, and the land has magic and the people are intelligent. Traveling in such a land reminds me of stories of ancient poets such as Su Shi and Bai Juyi. The four years of college life in Shanghai was very important to me. After I graduated from Fudan University in Shanghai, I came to Beijing to work at CCTV (Chinese Central Television).

What is the connection between your experience as a TV director and as a painter?

My career as a TV director was very important to my later painting. Much about painting, such as composition, color, the use of light and shadows, I learnt from my experience as a director and as a cameraman. I studied history and literature as well as visual materials to write my screen plays. I must think of how to present these stories and history through visual language. As a cameraman myself, I understand how controlling the shooting speed is crucial to presenting emotion. Shooting from up to down, near to far, cutting and connecting each shot creates different languages. Soft or strong, fast or slow, there is a feeling related to the topic you are representing. I produced projects on private libraries along the lower Yangtze River region that reflected a long tradition of *wenren* in southern China. I used different languages when producing projects on embroidery, and on the different operas of Sichuan and Tibet, which present very different emotions and styles. I had to understand the culture in order to design the visual language that includes camera setting and shooting speed.

I began to work on a series of works on Tibet along with my Tibetan photographer; he was my translator too. We became very good friends and went to Tibet numerous times together. One of my major projects was the "Tales of Tibet". I selected nine directors from China and each chose a few topics. I tried to avoid political opinions during research and presentation. I was interested in the life of the common people, and interviewed shepherds and nurses in Tibet. I followed a boatman who had a boat made completely from the skins of bulls—a balloon-like boat filled with air. He learned all kinds of news from his passengers and that is the way he learned of the outside world. I also made one section focusing on the Yalong River region, where Tibetan culture originated. Many Tibetan kings are buried there. This project was produced in a series of ten programs and was showed in China and Europe.

Another project that I worked on, but didn't have the opportunity to complete, was about the living reincarnations of the Buddhas in Tibet. I traced the process of how the young boys were selected as possible reincarnations of past living Buddhas. I visited the Taersi Temple in Qinghai province many times and observed all the religious festivals hosted there annually. Taersi Temple was the birthplace of Zongkeba who actually established the religious system of Tibetan Buddhism in the early 15th century. At that time, the lama in charge was the living Buddha Ajia, the nephew of a living Buddha Jiayang who was the teacher of the current Dalai Lama. I interviewed about ten Living-Buddhas, from four to 72 years old. They all had different experiences. They introduced and explained much to me, all in Tibetan.

How did the experience in Tibet influence you?

When you stand on the endless snow terrace and look at the piles of white skeletons, you understand the power of nature. No human traces can remain for more than two to three years. Whatever Chinese people tried to build there, did not matter how much money was spent, it was gone in a couple of years and no trace was left. Human effort cannot challenge the force of nature. After I worked in Tibet, I do not pay attention to small things. It certainly affected me and my life in a big way.

An Interview with Xu Bing

Translated by Wang Ying

Could you talk about the process of your composition, such as your "square word landscape paintings"?

I choose to portray whatever it is that interests me. It is not so much an inspiration; it is more the subjects that I've thought about for a long time. The subject fascinates me, and often presents a problem that bothers me. Therefore, the subject is the real material. You could use whatever you have at hand as your medium. What is crucial is what you want to say, but cannot explain.

My art came to me when I began to live in between two cultures. To live between cultures is not a comfortable situation. I had no reason to make such art when I was living in China. Another reason my work is the way it is, is that it reflects my interest in literature. The "square-word works" express what is inside me that I want to say.

What is it that you want to say?

What I want to express is my feelings about living between many different cultures. At a deep level, my interest has been focused on certain things. What I am attracted to is the unclear nature among concepts which itself is hard to define. I'd like to mess up the existing boundaries, and produce obstacles to the ways of thinking that people have become accustomed to. The concept of "square-word" is not applicable to express my work. Square-word is a falsification. It resembles its subject in what it is, but inside it, it does not truly represent its subject. It is just like my "Panda Project". The creatures only look like pandas, but are actually pigs. This disguise does not mean that the medium itself is not important. But after an exchange of identity as in my project, its true nature cannot be seen, and the falsified truth goes on being accepted. What I want to do in my work is to create obstructions to people's habits of thinking. There is a lazy nature to the way people think. Just like a virus, it repeats its structures over and over. When a virus gets in your computer, many of your computer functions are blocked. I am not a critique of Chinese culture or of cultural interaction. Today people use elaborate language to discuss simple ideas. In fact, contemporary art intends to be serious. The exhibitions frighten audiences at first by their extreme presentation. But when translated to the real world, they are well-known or even banal ideas.

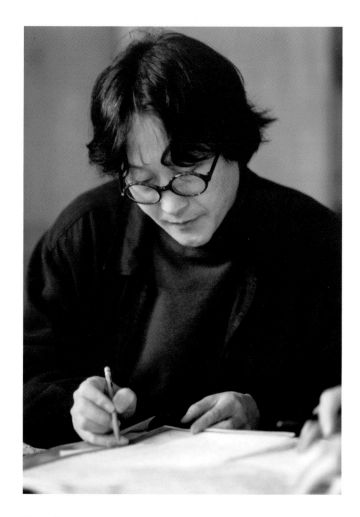

Figure 19a
Photo of Xu Bing

What I am attracted to is the unclear nature among concepts which itself is hard to define

I hope to break frameworks and stereotypes of thinking. I have always been challenging these things. My method is to appear to depart from the truth so that I can emphasize the truth. I do not feel any discontinuity in my creation. Wherever one lives, there are unresolved questions. Thus, I will not run out of creative material.

I am not clear about what I want to say. Because it is not clear, I create such works. The ambiguous feature is my reaction to the reality; it is a kind of sensitivity. Many scholars use Derrida's theory to discuss my works, especially my *Book End* Exhibition. Actually I had never read Derrida. It is a pure coincidence. If I knew about his theory, I wouldn't have bothered to do my works.

In fact, right after the Cultural Revolution, I joined many seminars and discussions, and was bored by them. In that particular historical period of the late 70's and early 80's, I read all kinds of books related to art. I read much like a hungry man eating too much all of a sudden and who could not digest it all. It was uncomfortable to me. I wanted to make a different book, my book, to express my feelings, not difficult theories of the profound, but focus on an essential topic-the possibilities of language. That was my feeling, in an artist's way, not as a philosopher who analyzes, but as an artist with true feeling.

How does this connect to your later works, such as the "landscape painting" and the three-dimensional words, such as "wood" and "stone"?
Those are based on my interest in hieroglyphics. Chinese thought can be traced to the nature of Chinese culture and its attitude towards esthetics and the understanding of beauty. Every Chinese character is a small painting. Chinese furniture, for instance, is related to the Chinese understanding of structure. If we look at Chinese written characters, such as the word for "window", in Chinese, chuanghu, 窗戶, refers to its physical structure. Following the cues that come from the sound and shape of words, you can discover the nature of Chinese culture.

I gained much of my understanding from studying *cunfa/tsunfa*, a particular brushwork used in Chinese landscape painting to present the texture and shape of material. Finally, I found out that each kind of *cunfa/tsunfa* and brush dot was related to the structure of a Chinese written character. As an example, each kind of tree in the Chinese system of writing contains a segment that represents wood-木, and each word of a type of tree contains both the part of wood-木 and the part representing that specific variety, like pane-松, willow-柳, and sandalwood-檀. *Cunfa/tsunfa* is same as character, which has an additional symbol to represent its particular variety. If we look at it in this way, *Jieziyuan Huapu* or *Garden of Mustard Seeds*, the printing manual used for painting instruction in China for more than a century, is really a dictionary that uses *pianpang*, or all the radicals that modify a character, and *bushou*, or section headings to explain all things in the entire known world. It is really a kind of metaphysics. The Chinese people view poetry, calligraphy, painting, and seals as one. I found a method to utilize them all in my word system.

When did you start to create this type of work? And when did you start your project of drawings by using only horizontal lines?
Since I went to the Himalayas, in Nepal, in 1999. I have always had a special interest in developing patterning. I have always enjoyed the challenge of using wood blocks. Early on, I created a print of a small farmland. It looked to me like a Chinese written character, similar to those in the newspapers. These types of surfaces, or "patterns," fascinated me, and led me into developing the use of written characters to draw sketch.

When I was in the Himalayas, when I was facing real mountains and water, they are difficult to describe in language. Words are too weak. At such moments I was made aware of what the art of Chinese calligraphy really is: that nature is the basis of calligraphy. The long-term argument since ancient times in China is how we define drawing or writing when we paint.[28] It is meaningless to discuss the art of calligraphy through the perspective of cultural studies. What is the art of calligraphy? What is style? When you face the real mountain to paint the mountain, it is calligraphy. Forget about all the "culture stuff"; use your own heart to feel directly—that is all the style you need. I do not know what the difference really is between drawing and writing.

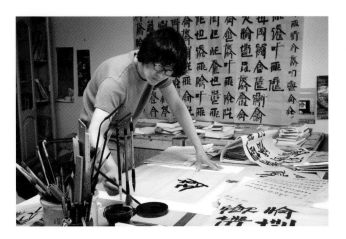

Figure 19b
Photo of Xu Bing

How do you understand the traditional Chinese saying *shuhua tongyuan*, that painting and calligraphy share the same origin?

In my understanding, these words are true. I have transformed landscape from the outside to the inside into the square-word landscape paintings. I use Chinese written characters, such as mountain-山, water-水, wood-木, and stone-石, to fill in the space where mountains and water should be arranged in the painting. Such a language can be understood by non-Chinese. Writing and drawing is the same thing. Many kids started to read the Chinese characters in my exhibition since it is obvious as to which one is a tree and which one is a stone. It seems that people share the same feeling towards Chinese written words and images. That is because people are the same, whether Chinese or non-Chinese.

What made you switch the subject and medium from the living animals of the Panda Project to the traditional medium of paper and ink?

There is no specific reason. I do not give much value to the choice of medium nor do I preserve a particular style. Any language and format can be used for a performance. There is no difference between painting and pigs, no old or new, no high nor low. To me, they're all equally interesting.

Could you talk about your "Reading Landscape," the three-dimensional extensions of Qing dynasty paintings that continue out of the boundaries of its frame on to the floor of the gallery as was displayed at the Sackler Art Gallery?

My work on extension of landscape began in North Carolina. For the Sackler Art Gallery show, I asked the curators to keep their original collections on display while I prepared my exhibition. There was a Yuan Jiang[29] painting on display and I decided to use it as part of of my creation. I added the three-dimensional characters to extend

Yuan Jiang's landscape all the way to the floor of the exhibition hall. Looking at ancient Chinese paintings, I do not feel the "poetic spiritual atmosphere" or *yijing* which people proclaim is there. In fact, I prefer to look at the published prints, which are clearer than the gloomy original paintings. In ancient times, it must have been a work full of spirit, but I cannot see it today. Time has changed it into a description/instruction. I can only imagine the lyric feelings that it may once have held. Ancient Chinese people favored black and white images and saw calligraphy without color as being more related to Chinese philosophy. Chinese painting did contain spirit/mood. But today, such a mood comes from my imagination and not from the painting itself. So I decided to enhance the ancient paintings.

What, in your understanding, is unusual about Chinese landscape painting?

Chinese landscape painting is formed of symbols. There is no need for the artist to go out to make a sketch from actual nature.

Didn't artists of the Song to Ming Dynasties (10-17th century) sketch from nature?

Yes, but gradually they created an entire system of symbols. They established a program of symbols for the use of brush lines.

Could you tell us a little about your initial reaction as an artist to the differences in the two cultures when you first came from China to the United States?

In the beginning I did not feel as strong and clear in my work, as I had felt in China. I could not understand things accurately. I was more familiar with the culture and art of China. Only after I acquired a good understanding of the society I now live in, could I possibly have the sensitivity and abilities to create good work. When I first arrived here, I did not have that sensitivity which I had in China.

Did you feel free as an artist in the United States, in that you could make whatever you wish?

I did not have such a feeling. The pressure and limits here differ from what we had in China. First of all, there was the barrier of language. I did not speak much English when I came, so the pressure and stress was much heavier than I had ever felt before. I did go to English school but did not learn much. For example, in English class I was taught a word "shopping-cart". What is it? I had never seen it in China and did not know what it is. I did not continue my English class after a year, and English was my biggest difficulty. This world is complicated. There is no place that has absolute freedom. I am staying here because I have so many projects to do. That makes it worthwhile to stay here for now.

An Interview with Zhang Hongtu

Translated by Yan Sun

Let's start with your new series on traditional Chinese *shanshui* (mountain and water) in Impressionist style. What are the differences between Western landscape painting and *shanshui*? Why do you prefer *shanshui*, the original Chinese term to denote a painting on nature?

Some people may think I am splitting hairs over the differences between these two terms. In the US, *shanshui* is normally translated to "landscape painting." These two words come from different language contexts, and cause confusion during translation. I don't think *shanshui* can be correctly translated into English at all. Traditional Chinese paintings have different categories, for example, *shanshui*, birds and flowers, and architecture. In the West, however, most outdoor paintings are termed as landscape paintings. A painting of nature in China is called *shanshuihua*, or a picture of mountain and water. It is because you always see *shan* (mountain) and *shui* (water) in these paintings. The *shan* is always still and the *shui* is always flowing. Chinese artists considered *shan* and *shui* as symbols of nature that were related to the yin and yang concepts.

In some Chinese paintings, the *shan* has a particular name and refers to an actual mountain. For instance, in Shen Zhou's (1421-1591) paintings, he depicts "Supreme Mountain Lu," but we know that he never visited Mount Lu. What is interesting is that nobody has ever questioned whether or not Shen Zhou's Mount Lu is an accurate depiction of the same. Why is that? Because it is not of concern to Chinese artist and scholars.

On the contrary, European paintings from the Renaissance period to the Impressionist style focused on realism. What you see is what you paint. Even Van Gogh's emotional brushstrokes and Cézanne's emphasis on geometrical forms are closely based on nature and directly painted from nature.

Song dynasty shanshui painters such as Fan Kuan also intended to depict nature realistically. How do you distinguish these artists' attitudes towards nature with the comments you made on Van Gogh's and Cézanne's painting?

When I talk about nature, I consider it in more general terms. In the Song dynasty *shanshui* paintings that you mentioned, the artist is concerned more with the relationship between human beings and nature rather than nature itself. Human beings are always depicted in small scale; same with a tree or a pavillion. Nature is already in its ideal form. For example, a famous *shanshui* painting by Wang Shen indicates otherworldly nature. No one has ever questioned why his painting is not a direct depiction of nature. Chinese consider nature as an ideal environment. It is more about how the artist understands nature. This is the so-called "*xinxiang*" (images reflected in heart), neither a depiction of the physical form of nature, nor a simple transformation from the three-dimensional world to a two-dimensional painting. In the West, when we talk about landscape paintings, we already have an idea as to how it is supposed to look. If we use this preconception to talk about Chinese *shanshui*, we may not be able to understand it in the Chinese context. Of course, these are questions for scholars, but while I paint, I think about these questions and share them with my friends.

What are the significant differences between the two?

This is what I mentioned before. If the Western audiences don't use the term landscape, they will not use the preconceptions associated with them to analyze Chinese *shanshui*. They will ask you why it is called *shanshui* and how *shanshui* developed in different periods in China. For example, in European history of landscape painting, there is a progression from realism to abstraction. However, Chinese *shanshui* does not have this trajectory. I hope the Western audiences will try to view the *shanshui* in a Chinese cultural context. Landscape and *shanshui* are just two different terms that view the painting of nature with different perspectives.

While I paint, I make some comparisons. In Cézanne's landscape paintings, for example, there is an occasional human being, but I believe the colors and the structure of the mountains are his main concerns. Human beings are not emphasized in his paintings. In Van Gogh's landscapes, we see strong emotional expressions, and a human being's presence in the landscape only enhances this aspect. In the *shanshui* of Chinese artists like Ni Zan's (1301-1374) and Dong Qingchang's (1555-1636), there is no depiction of human beings. The compositions, the use of ink, and the brushstrokes are more important. Another comparison between *shanshui* and European painting would be in the use of color. During the Song dynasty, colors such as blue and green were used in *shanshui*. The color is beautiful and attractive and conveys a strong visual

Discover your true self in the work. That is true freedom.

effect. However, when *shanshui* painters turn their focus on to brushstrokes, the structures of the mountains and the spirit of nature, color is redundant. It really reminds me of Duchamp's works. In his *Nude Descending a Staircase*, color is not the main concern, and yet we cannot say that Duchamp did not know how to use color. What he pursued is a concept of how to represent movement and space on a two-dimensional surface. When I think about these questions, I don't think I am a Chinese artist in the traditional sense.

What is Duchamp's influence on you?

The most significant influence is his idea that painting does not have to recreate a strong visual effect or stimulate the sensory perceptions in any way. What is more important is something behind the canvas. When we look at Duchamp's paintings, the first impression we have is of being refused entry. There is a delayed perception in Duchamp's paintings, which is very different from the first impression one gets from looking at Van Gogh's paintings, where strong colors and distinctive brushstrokes make an immediate impression upon us. This delay in absorbing the painting allows the audience to readjust their perception.

What kind of information do you want to deliver to your viewers?

I don't want to impose any ideas on the audience. I want every viewer to reach his or her own conclusion. I want to propose some questions related to the multi-cultural world we live in. For example, I want to pose the questions: What is traditional Chinese painting? What is western painting? What are the boundaries between them? I don't want to simply label my work and myself in one way or the other, for when one is labeled, one is confined.

What then do you want to represent in your *shanshui*?

I do not intend to represent an ideal nature as in the Song dynasty *shanshui* paintings. My work is an ideal painting in terms of the composition, the color, the form, etc. In the Song dynasty *shanshui* painting, what attracts the viewer is the otherworldly feeling and not just the brushstrokes or the use of ink.

Your idea is to create an ideal painting. Why do you use old models instead of creating your own?

My works have always been related to pop icons and their use in art, such as the use of Mao's image. Those icons already have the power of having caught the popular imagination and can be easily recognized by the audience. In my understanding, the Chinese *shanshui* has already become such an icon to the modern viewer. Chinese *shanshui* and Impressionist landscapes and prints in museum collections are the major sources for my creation. Only some paintings are based on my actual memory of the landscapes in China.

Do you use Chinese *shanshui* and impressionist landscape as your models because you also want the audiences to focus on the meaning of the mixture?

That's possible. In my paintings, I can freely play with the concept but not the color, brushstrokes and compositions. I used to think about using my own preference for color to paint. There are two issues that arose from it. First, it is not a "play with an icon" game any more. It is my own personal expression. Second, the audiences are not necessarily familiar with my personal expression and it may not matter to them. For me, the concept is more important than the style or the visual effect.

To us, your landscape paintings also have a strong visual effect. For example, you write Chinese calligraphy and paint seals over the layers of oil paints. This creates a strong visual effect. How do you conceive of that in the first place?

It took me a while to reach the stage I am at now. I started the series in 1997. At the very beginning, I barely wrote on the painting. I did not even include the texts on the original Chinese painting. I thought that I had already made a detour when I painted the Chinese *shanshui* in Impressionist style. I was afraid that the Chinese characters would make the painting lose its balance even further. Later, I noticed that this very inconsistence was the main feature of my painting, so why not emphasize that? So I added all the texts and the seals on the original Chinese *shanshui*. I also added my own seals. I wanted to enhance the traditional concept in Chinese art history, which is the consistency of the poetry, calligraphy, paintings, and the seals.

The style of your calligraphy looks like print style calligraphy rather than handwritten. Can you tell us why you choose this kind of style?

At the very beginning, I used the calligraphic style I liked. The style is between running scripts and official scripts. Later, I noticed that my personal style was not evident in my painting. I used the composition of traditional Chinese shanshui and the color of the Impressionists. I thought my calligraphy should be similar too. Now I write in the Song dynasty style script that was traditionally used for printing [At this point, Zhang Hongtu led us to the paintings in his studio]. For example, in this painting, these are the imitations of Wang Hui's original calligraphy. All my own calligraphy is written in the Song

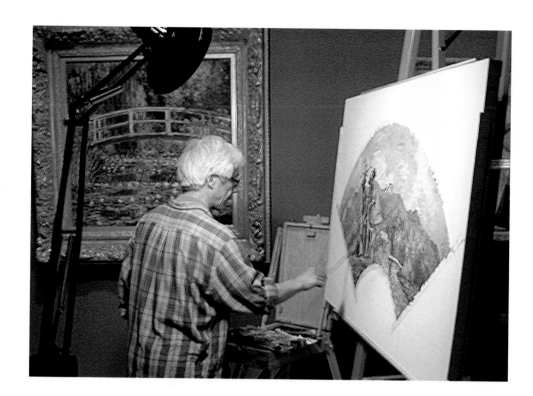

Figure 20
Photo of Zhang Hongtu

printing style. I also used the seal "Henan is my home country". In this Guo Xi-Van Gogh painting, I did not write any texts when I initially painted this work in 1998. All the texts such as Emperor Qianlong's poem were added later in the winter of 2002.

How do you match the style of Van Gogh, Cézanne and Monet's work with the Chinese *shanshui*?

This is a big issue. It takes some research to match two paintings. While I was still in middle school in China, I loved Impressionist works, but we were not allowed to paint in that style due to political reasons at that time. Although I did not work on the series right after I moved to the United States, I already had a large amount of information about the Impressionists' work in my mind. Then I started to study Chinese *shanshui* paintings. For example, this is Van Gogh's painting depicting dust, clouds and trees. The composition of this painting matches a landscape by Li Cheng. I plan to paint this very soon.

Bada (Bada Shanren 1625-1705) and Shitao's (1630-1707) *shanshui* feature very individual styles and the whole picture suggests movement. I normally use Van Gogh's style to paint their *shanshui*. Dong Qingchang and the Four Wang's shanshui can be characterized as well-organized composition, with the use of the geometric forms and the lack of human activity. These features fit well into Cézanne's style.

As for the Song dynasty *shanshui* paintings, they were picked on an individual basis. For instance, I have used Fan Kuan's "Travelers' in Mountains and Streams" twice already, for which I used both Cézanne's and Van Gogh's style. It is not because Fan Kuan's

brushstrokes look like Van Gogh's. In Fan Kuan's painting, we see gigantic mountains, powerful waterfalls and his passion toward nature. It matches the enthusiasm and brightness in Van Gogh's painting. I think the monumentality in Cézanne's works indicate similar feeling. Another example is Shen Zhou's "Evening Rain" which is a perfect match for Monet's style.

How did you first start the Chinese *shanshui* in Impressionist style?

This is related to my Mao series, and my interest in "playing with icons" and my own personal experience. Between 1996 and 1997, I realized that I lost my interest in Mao. The reason I did the Mao series in the first place was that it was a form of psychotherapy. I started with painting Mao's image on the container of a Quaker Oats box. The face on the box bears a striking resemblance to Mao. I felt nervous and guilty while I was cutting Mao's images for a collage. It would jeopardize my career if I did that in China as some of my Chinese friends had pointed out. This kind of guilty feeling became a motivation for me. I thought about it some more. Why am I able to use Bush's and Clinton's images freely but not Mao's, even though Mao has already been deceased for many years? I felt that it was really my own psychological barrier. To the Chinese of my generation, Mao's image was very special. However, to Andy Warhol (1928-1987), Mao's image was no different from Campbell soup's and Marilyn Monroe's. My Mao series ended when my guilty feeling was gone and Mao ceased to have power over me. Then I started

to create some works related to my life here in New York such as calligraphies done with soybean sauce.

In the late summer of 1997, I received a commission from Forbes magazine. At the time, I had just returned from Beijing after my first visit since I started living in the United States ten years before. The magazine asked me to paint four paintings as advertisements. I chose the poster style of the Cultural Revolution, with the red colors and the revolutionary mood. The slogan on the painting said "capitalists of the world unite." I don't like the style of the Cultural Revolution. This work, however, made me think about how to revive a traditional style. My first work in the series started with Fan Kuan's "Travelers' in Mountains and Streams" in Van Gogh's style in 1998. To me, this is not just an artistic and aesthetic question. It carries social messages as well. There is no pure American art or Chinese art in the contemporary world.

In some of your earlier works in China before your Mao series, it seems to us that you carried a burden and your works often indicate your concern with the future of China. Can you comment on that?

To me, it is a mixture of my instinct and responsibility. It is also related to my art education in China where I was taught that art should serve the people and should be understood by all. I still think these ideas are valid. However, my take on it is different from Mao's interpretations of art. Art should not be a political tool. It is a way of communication. When I was in school, I was told that China has a rich history and that our mission was to restore its past glory. When I was in China, I did some work related to Chinese history such as Dayu (a legendary king) managing a flood and Kuafu (a figure in early Chinese mythology) chasing after the sun. After I moved here, I wanted to forget all of these. It became a burden for me. I have a rebellious attitude. I want to look at Chinese culture and history from a new perspective.

There are mixed feelings evoked by my *shanshui* paintings. Some Chinese criticize the fact that I apply color on Chinese *shanshui*, for traditional Chinese literati valued *shansui* done in pure ink. Color was considered vulgar to Chinese literati artists. To the traditional Chinese literati, sensual impact should be reduced to a minimum. I don't think my paintings fall into the category of traditional literati painting. However, sensual impact is part of contemporary life, so why not enjoy it? I don't expect everybody to agree with me, but I do want them to think about these questions.

At the very beginning, I wanted to combine the traditional Chinese painting with the contemporary Western art. I painted some abstract paintings on rice paper in bright colors. I thought this would be the fusion of two cultures. Now I think it is a superficial imitation of abstract painting.

My idea was changed by a show at the Guggenheim museum. In the catalogue of the show, it said, "National art is bad, good art is national." I always thought that our national culture was our roots, especially to the Chinese coming to the United States. After reading that, I suddenly understood that a successful work should be judged by its quality and impact on the audience and not by the nationality of the artist. This allowed me to be relieved of the burden of my own national art.

Color was a major concern in Chinese painting before the Song dynasty. The frescoes at Mogao caves carry strong colors. Can you explain how folk-art still preferred strong colors during and after the Song dynasty, while scholars looked down on any sensual stimulation?

This is a very big question. It is related to Daoist philosophy and Chan (Zen) Buddhism. Traditional Chinese artists were not interested in representing the three-dimensional world even when Jesuit painters such as Lang Shining (Giuseppe Castiglione 1688-1766) brought new points of perspective to China. It never stimulated the interest of the scholars. I believe this is also related to the actual Chinese scenery. When you look at mount Huang in distance, what you see is a silhouette among the clouds, not the color. All these contribute to the reason why Chinese literati painters preferred ink and simplicity. For Common people though, since their life was already very dull, they needed the stimulations of color. In folk art and music, sensual stimulation is very important. The idea of my *shanshui* paintings is to urge people to think about these questions.

You create some interesting pieces, such as the bronze McDonald wares and the Coca-cola bottles in blue and white porcelain. McDonald and Coca-cola are symbols of American pop culture. Can you talk about your concepts behind these works?

This can be traced back to my Christie's catalogue series. I started the project after I came back from Beijing in 1997. I told my friends that I had a second cultural shock. The first is coming to the US and the second is going back to my home country, for fast-food chains like McDonald's were everywhere in Beijing. That's how I started. The earlier works in this series are all digital images.

Later, you cast McDonald wares in bronze and made Coca-cola bottles in porcelain. Bronze and porcelain are both traditional Chinese materials. Can you talk about why you picked them?

Most of the Chinese works auctioned at Christie's were ancient art objects and these ancient arts were like icons to me—they were mostly bronzes and porcelain objects. So I picked bronzes for McDonald containers. Drinking Coca-cola is already part of everyday life in China. When I was in China, I was asked how I wanted to drink the Coca-cola: Cold or hot? The hot Coca-cola with ginger

is a Chinese invention. I was amazed to see how fast American pop culture has been introduced in China and how Chinese have accepted and modified them as their own. So I used blue and white porcelain, and not the glass bottle. Coca-cola is a favorite drink amongst the young. Ironically, this is not a healthy drink for children. So I intentionally copied the scene of children playing at the courtyard from the Ming blue and white porcelain.

We are also interested in your background and experience. Can you talk about why you wanted to come to the United States?

China in 1982 was so different from China now. At the time, there was no way to change one's job. When I was growing up, I wanted to become a well-known artist. After I graduated from high school and applied to the Central Academy of Fine Arts, I was not able to enter the Academy. That year the Academy did not recruit any students. Instead, I was admitted into the Central Academy of Arts and Crafts to study porcelain. We had no classes for three years during the Cultural Revolution. Then we were sent to the countryside. My work had nothing to do with my training at school. I was invited to teach at several prestigious institutions in Beijing. However, my institution did not allow me to change my job. It was very hard for me to continue the work I love. Under those circumstances, I felt that there was no future for my career. So I came to New York in 1982 on a student visa. I studied at an art school here, and also worked to support myself.

What's your connection with the contemporary art world in China? Have they seen your work in China? What's their reaction?

The art world in China is still trying to understand my work. I hope I can exhibit my works in China sometime in the future. It might be true that the environment now in China is good for my career development. However, living in New York really gives me the advantage to get in touch with different cultures. The diversity of the culture in New York is the result of globalization. My exposure to this will constantly stimulate my creation.

If you were asked to give some advice to other immigrant Chinese artists, what would you want to say to them?

Discover your true self in the work. That is true freedom.

What do you think about the future of contemporary art?

I don't predict the future. Mainstream art is just one perspective to look at the art. The contemporary art world also emphasizes diversity. The boundary between the mainstream and the margins will blur in the future.

Gu Wenda

**Forest of Stone Steles–Retranslation and
Rewriting of Tang Poetry (1993-2004)**
Regan Golden-McNerney

Wenda Gu's Forest of Stone Steles includes fifty stone slabs
individually inscribed in China with several interpretations of Tang
Dynasty poems. Each slab includes a version of the poem in
Chinese, a translation of the poem into English, and phonetically
back-translated from English into Chinese, using the *Gushi Jianzi*,
or his eponymous Gu Style Simplified Character. Wenda Gu also
generates a new poem from sound which he has created through
this process of translation and reinterpretation. Gu's work with the
stone steles reveal that language is transmutable. In the process
of this transformation of languages, Gu challenges the viewer or
reader to reconsider the idea of language and identity as a fixed
entity driven by the borders and traditions of a nation, what is "set
in stone" becomes readily alterable. In the *Forest of Stone Steles*
installation, Gu also aligns himself with the poet/artists/scholars of
the Tang dynasty, who often coupled poems with images on painted
silk scrolls. The absence of an image to be paired with each poem is
significant in the *Forest of Stone Steles*, because the arrangement
of the text on each slab suggests that the words themselves, the
shapes of each letter both in English and in Chinese, is the image.
In contrast to the use of text in the *united nations series* where the
words woven into the hair seem to be lifted into the air, the stone
steles hover just above the gallery floor providing a different type of
departure point for the human spirit.

Plate1
Gu Wenda, retranslation and rewriting of
Tang poetry, a digital image

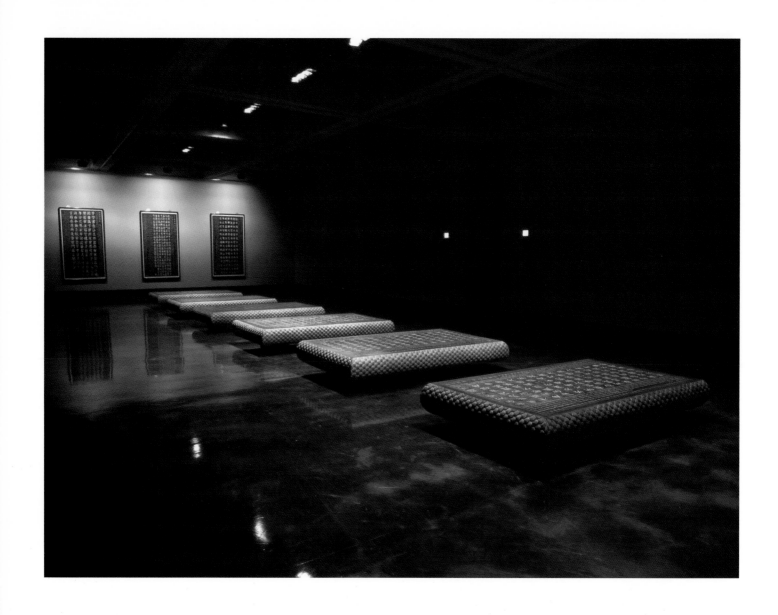

Plate 2
Gu Wenda, steles on display, stone,
75 x 44 x 8 inches each, 1993-2004

Plate 3
Gu Wenda, steles on display, stone,
75 x 44 x 8 inches each, 1993-2004

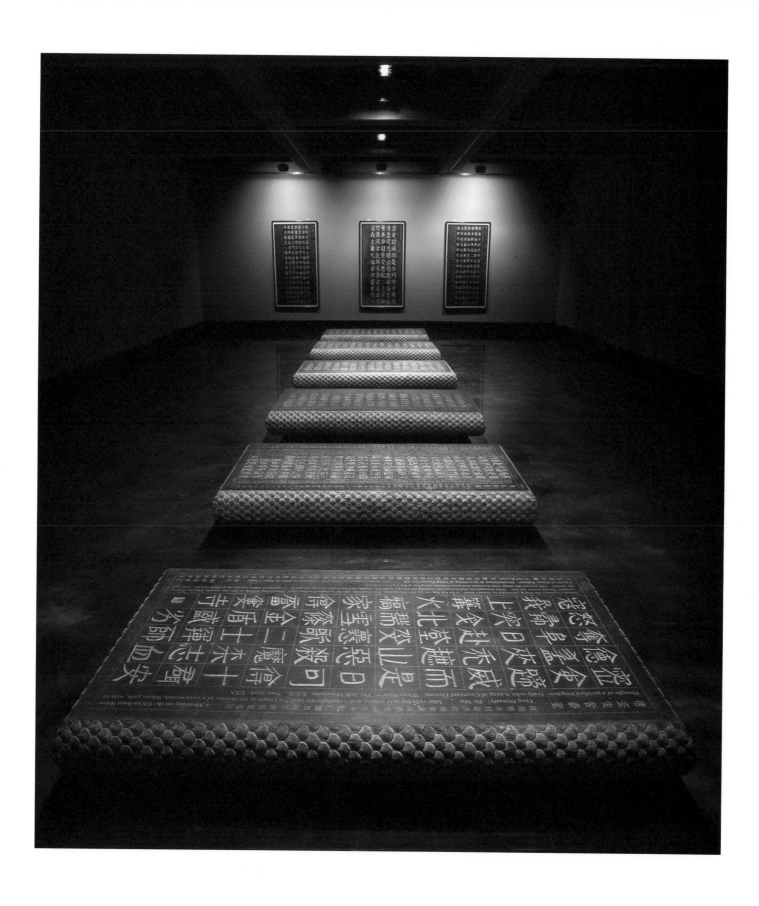

碑林 - 唐詩後著
forest of stone steles - retranslation & rewriting of tang poetry

谷文達

序言

我在一九九三年開始構思現代碑林此一龐大的計劃。經過數年反反復復的研究後使之觀念和形式臻于成熟。又經歷了無數次在實地對石碑的種類和質量的考查，對石碑專業刻工和拓片技術人員調查，最後在西安碑林博物館和陝西中國畫院的大力協助下使各個方面都達到了指標。此現代碑林採用的是名爲"墨玉王"的石頭，石質細膩而堅硬，石色墨黑，產自于陝西省境內臨近西安市的唐代皇帝李文宗(李昂)的陵墓(公元八四〇年)。石塊均由傳統的手工和機器開採，而不用爆破開採法。歷史上的西安碑林的石頭皆出于此礦。並在西安碑林博物館專家的配合下找到了一流的刻，拓人員。此現代碑林的第一系列的工程已動工。

現代碑林的第一系列爲五十塊石碑。每一塊均爲 *110 cm* 寬 *x 190 cm* 長 *x 20 cm* 厚(約重*1.5*噸)。石碑表面抛光爲 *70* 度即光滑平整而無反光。石碑呈躺臥式而不是直立式。石碑的四週邊呈半圓形並雕以龍身魚鱗紋。

此五十塊石碑的主碑文爲<<唐詩後譯>>。此主碑文是以美國四十年代的唐詩的著名英譯本<<翡翠山>> (*The Jade Mountain*，譯者是 *Witter Bynner*)爲范本，再由我以此唐詩英譯本的英文之聲韻來選擇中文同聲字譯回成漢語，並由此構成新詩。然後此主碑文由我的正楷書法完成並鐫刻于石碑上。而唐詩原文，唐詩英譯文則作爲碑文的和跋和註解以細小字體刻于主碑文之下。唐詩是中華民族燦爛的文化遺產之精髓。

1

詩又是集文學和藝術爲一體的典範。當她被譯成英語或其他語言時，除了語義的翻譯之外，完全喪失了唐詩的音韻美學。更何況音韻本身亦傳達詩的內涵。而我的<<唐詩後譯>>則以唐詩的英譯文的讀音再譯回成漢語，尋出英語的漢語同聲字，然後重構"後唐詩"。而她卻成了極盡荒誕的新詩。通過此一近乎哲學方法論的演譯，一種文化的"出口"，經過它種文化的"消化與消解"，再"進口"回本土，"唐詩後著"成了多元文化的"異化"的新品種，或者對經典唐詩而言，卻成爲可笑而荒唐的"誤解"。

可以想象如果以此方法論的方式去創作文學詩歌，她不但介入了和超越了"單一細胞文化"，同時由于激發創作的想象力基于此嶄新的語言文字學方法論，她同時超越了人腦有限的想象力。以一首唐詩爲例，如果在漢語與英語之間以"音譯"與"意譯"交替來回翻譯一百次，她將成爲一部奇異的長篇小說。

<<唐詩後譯>>可以作爲"文化基因學"的一個特殊範例和現象。同時，對<<唐詩後譯>>的現象所採取的態度與立場是文化的批判主義還是文化的進化論，這取決于我們及每個人對于歷史，現時及未來的回應。

<<碑林>>是中華民族文明的一部燦爛的史實與史詩。她也是一個精彩而豐富的博物館集歷史，文化，藝術和技術于一體。我的現代碑林的創制是依據此一經典形式，並基于我們賴以生存的二十一世紀，在不同的政治與社會，科學與文化之間展現了史無前例地愈演愈激的互相影響和制約，綜合與解體，同化與异化的現實。我創制的新<<碑林>>不是中國古代<<碑林>>之延續，而是從一個側面去譜寫當代史。在我的碑文中可以意讀我們當代社會中由于科學，通信，運輸等的進化與發展，不同的人種和文化的不斷"進口與出口"，"混合與雜交"等等錯綜複雜的後文化和後殖民的現象。人種，政治，科學與文化的特殊共性：異化 - 反異化 - 互相異化。

2

44

<<碑林‧唐詩後譯>>如同<<聯合國>>，<<墨術>>，<<茶術>>，<<中國簡詞>>等均爲我的主題爲"從中國文明至生物代的千嬉年"系列中的幾個不可分割的重要部分。

<<碑林‧唐詩後著>>的書法風格和文字結體：
一，五十塊石碑鐫刻著五十首"唐詩後著"，每塊碑爲一首。

二，每塊碑上刻有唐詩的四種譯文：
1，原唐詩。原唐詩的字體爲繁體仿宋印體。
2，原唐詩的英文譯本是根據維特爾拜納爾 witter bynner 的唐詩三百首 (jade mountain , new york)。字體爲 time new roman 的印刷體。
3，是"唐詩後著"(即主碑文)。是根據維特爾拜納爾唐詩的英文譯本之英語讀音選擇同聲漢字而重著的"後唐詩"。主碑文的字體是我創造的繁體正楷書法。
4，在將我的後唐詩譯回成英語。字體爲字體爲 time new roman 的印刷體。

三，碑的後唐詩(即主碑文)是整個碑的主體。是以我獨創的繁體正楷書法鐫刻而成。其風格在傳統的正楷書法的基礎上融入了篆體和仿宋體。在風格上比傳統的正楷書法更渾厚(篆書)和更硬朗(仿宋字)。

後唐詩(即主碑文)的漢字結構我也作了新的設計。我設計的漢字的結構主要在兩個方面體現出來：

一，"統一"。
所謂"統一"是將左右邊旁構成的傳統漢字的左邊旁挪至右邊旁之上方，比如"吻"字變成了多字。再舉一例"狸"字變成了童字。或者將左或右的一個邊旁擴大到另一邊旁的上方，比如"橫"字成了蘈字，再舉二例："亂"字成了氰字，"徙"字變成了徒字。這樣，使傳統漢字成爲無左右邊旁構成的漢字了我稱其爲"華蓋天下法"(見附圖

)"統一"的另一方法是將左或右的一個邊旁擴大到另一邊旁的下方比如"塔"字成了荃字。又比如"肛"字變成了肓字。我稱此法是"潛心坐禪發"(見附圖)。

二，"還原"。
"還原"是將傳統漢字構成中以"字"作爲的邊旁的方法還原。例：從"波"字變成发字，即將"三點水"還原成"水"。再舉例：從"列"字到另字，將"立刀旁"還原爲"刀"。我稱此法是"還其眞相法"(見附圖)。

谷文達

一九九九年于紐約

3

4

Plate 5
Gu Wenda, Introduction to Retranslation
and Rewriting of Tang Poetry, in Chinese

唐詩後著

Retranslation & Rewriting of Tang Poem No.11

唐: 常建　　　　　　破山寺後禪院

清晨入古寺，初日照高林。曲徑通幽處，禪房花木深。山光悅鳥性，潭影空人心。萬籟此皆寂，惟聞鐘磬音。

Tang Dynasty: Chang Jian
A Buddhist Retreat behind Broken-mountain Temple
In the pure morning, near the old temple,
Where early sunlight points the tree-tops,
My path has wound, through a sheltered hollow
Of boughs and flowers, to a buddhist retreat.
Here birds are alive with mountain light,
And the mind of man touches peace in a pool,
And a thousand sounds are quieted
By the breathing of a temple-bell.

(以 Witter Bynner 的唐詩英譯本 Jade mountain 之英語讀音的同聲漢字譯回成中文)

迎日飄旄，濘泥在甌潭坡。巍峨禮頌，籟咆音刺日，趨濤波逝。馬怕嘶駭，詩翁的寺麓，啊，瀉邇的豪樓。鼇伏霸河山，德府樂舞獅。突罷怖，笛嘶力驅。黑波鯊來伏，威勢猛騰勒崖頭。安得日幔，鬥夫滿塔，卻似劈星扼魄。庵大韶山的松姿啊，跨崖蒂德。拜則比逸興啊，浮鵝潭泊百鴝。

(retranslated back to english by Wenda Gu)

Fluttering banners bathe in sunlight on the muddy Ou Tan hillside. Lai Paoyin bayonets the sun while ode flies and, hastily, the waves disappear. The horse screams with fear. Oh, how gorgeous is the waterfall mansion by the old poet's mountain temple. A crouching chela in an overbearing universe and a happy lion dance at De's house. Suddenly, terror shouts with a powerful move when a black shark jumps to forcefully rein in the cliff. Split stars clutch the fighter's spirit of a crowded pagoda. Oh, cross the Dide to see the pain on An Da Shao mountain. Worship when hundreds of emus rest by Fue pond.

唐詩後著第十一首是碑林第十一碑的碑文。The text of *Forest of Stone Steles* No.11

Plate 6
Gu Wenda, Poem of Chang Jian and Gu's
Translations

唐詩後著

Retranslation & Rewriting of Tang Poem No.8

唐：柳宗元　　　　　江雪

千山鳥飛絕，萬徑人　滅。孤舟蓑笠翁，獨釣寒江雪。

Tang Dynasty: Liu Zongyuan　　River-Snow
A hundred mountains and no bird,
A thousand paths without a footprint;
A little boat, a bamboo cloak,
An old man fishing in the cold river-snow.

(以 Witter Bynner 的唐詩英譯本 Jade mountain 之英語讀音的同聲漢字翻回成中文)

啊，酣覺得夢，登山拿波島。啊，搜神湃思，未饒塔府得百靈。啊，樂
透謳帛塔，斑布刻寥廓。啊，懦弟躕肥形，飲日渴耳，得利復而思惱。

(retranslated back to english by Wenda Gu)

Oh! Dream deep in sleep, of climbing Napo island. Oh! Search for spirited, turbulent
thoughts, without knowing the pagoda's hundred spirits. Oh! Sing a happy song, for the
silk tower is carved with the universe. Oh! A cowardly fat man drinks the sun and dries
his ear, he worries while getting his benefits.

唐詩後著第八首是碑林第八碑的碑文。The text of *Forest of Stone Steles No.8*

Plate 7
Gu Wenda, Poem of Liu Zongyuan and
Gu's Translations

Plate 8
Gu Wenda, Poem of Wang Bo, ink
tapping on paper, 71 x 38 inches

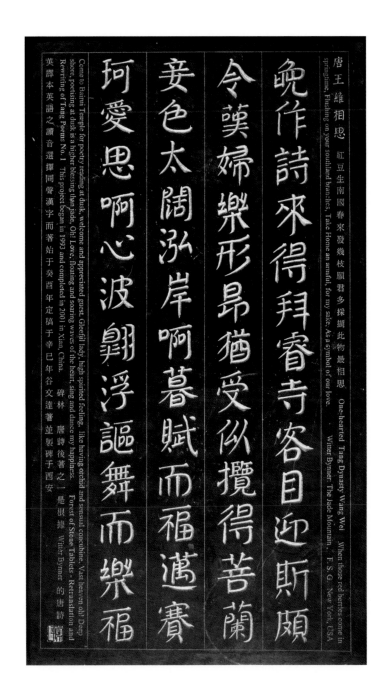

Plate 9
Gu Wenda, Poem of Wang Wei, ink
tapping on paper, 71 x 38 inches

49

Plate 10
Gu Wenda, Poem of Wei Yingwu, ink
tapping on paper, 71 x 38 inches

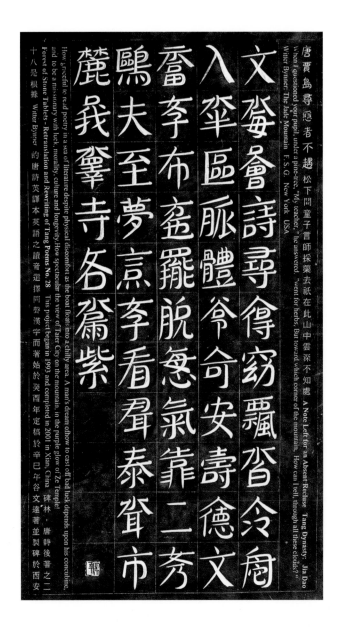

Plate 11
Gu Wenda, Poem of Jia Dao, ink tapping
on paper, 71 x 38 inches

51

Wang Mansheng

Distant Heart Studio
Wang Mansheng

I have given my studio the name Distant Heart Studio. The reference
is to a poem by Tao Yuanming (365-427) of the Jin period. The fifth
of his series of poems "Drinking Wine" begins:

I built my hut in the world of men,
Yet there is no din of carriage and horse.
You ask me how this could be so:
With a distant heart one's place becomes remote.[30]

Even in the midst of clamor and chaos, with a calm mind and heart
it is as if one is in distant mountains. Because I have moved about
a lot in my life, I have never had a true studio, only my seal and that
place within myself where I retreat to create. My work has also often
taken me far from family, friends, and teachers. Each time I place this
seal upon a painting, I think of those loved ones from whom distance
separates me.

(1999)

Plate 12
Wang Mansheng, Study of Buddhist
Figures, 17 x 14 inches, ink on paper,
2004

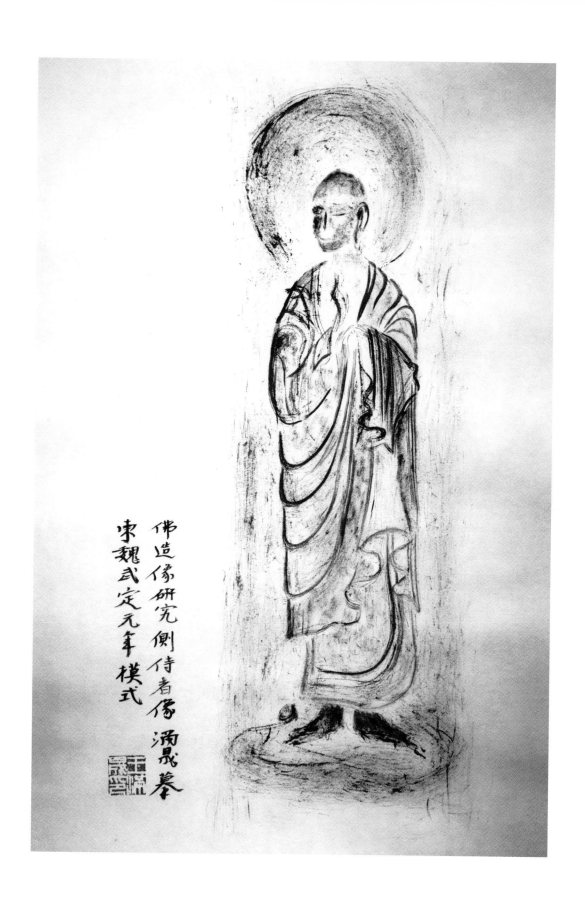

佛造像研究 側侍者像 溜晟摹
東魏武定元年模式

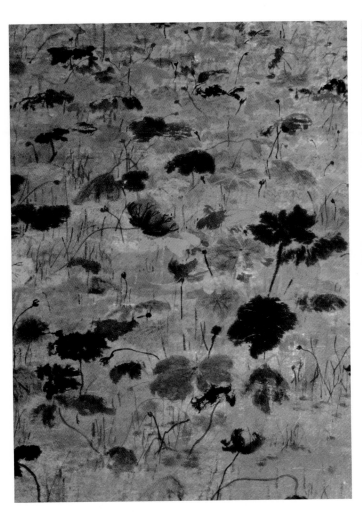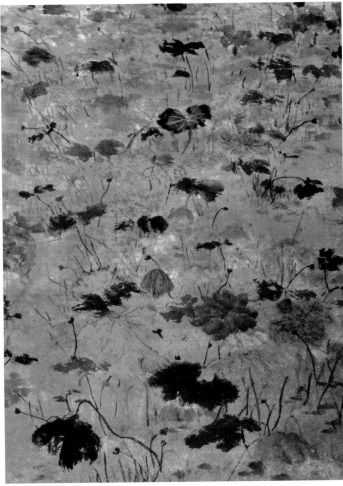

Plate 13
Wang Mansheng, Lotus Pond in Deep
Autumn, 83 x 31.5 inches each panel, ink
and color on paper, 1998

Dreams of the Blossoming Brush
Wang Mansheng

[This description was originally written for Wang's Exhibition at the Piermont Flywheel Gallery, September 21-October 8, 2000]

The name of this show, *Dreams of the Blossoming Brush*, derives from an old Chinese story in which the poet Jiang Yan (A.D. 444-505) dreamed that an immortal gave him a brush with flowers of five colors blooming from the tip. From that time on, his essays and poems were exceptionally fine. Since childhood I have aspired to write and paint well. I put down my career as a television director when I moved to the United States in 1996 for the birth of my daughter, and my focus has now shifted full time to painting. In these past four years I have had to not only learn, literally, a new language, English, but also the languages to be found in the rhythms of a new country and the joys and trials of raising my daughter, as well as in the challenges of improving my art. The energy of my dreams inspires and infuses each aspect of my life, and I hope each will, in its own way, flower.

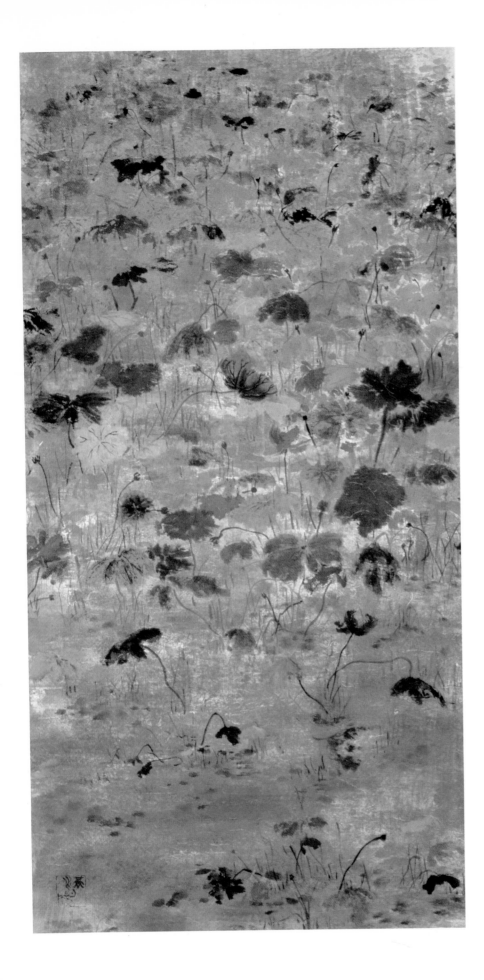

Plate 14
Wang Mansheng, Lotus Pond in Deep
Autumn, left panel, 83 x 31.5 inches,
ink and color on paper, 1998

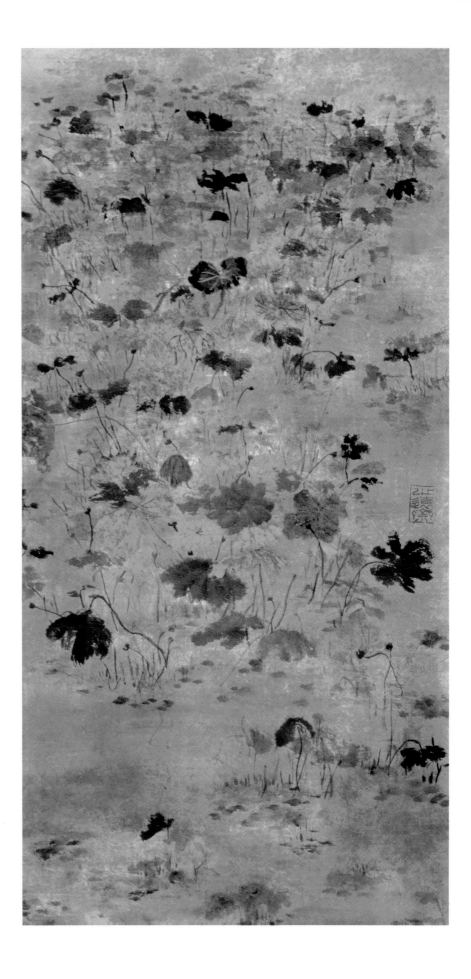

57

Reflections On Tradition
Wang Mansheng

The older generation uses language, expressions, and actions to convey to the younger generation the accumulated experience and knowledge of those who came before. The younger generation uses eyes to look at, ears to hear, hands, feet and bodies to copy and try out what has been taught, while also adding to and developing it. This becomes tradition. The longer a people's history, the more traditions are created.

China, with its long history, is naturally rich in traditions. One such tradition is that children begin to practice calligraphy with a brush at age five or six. I was quite attracted to this idea, but my childhood fell in the midst of the Great Proletarian Cultural Revolution, a merciless attack on Chinese traditional culture. No one dared teach traditional wisdom, and books on such subjects were nowhere to be found.

Yet even under siege traditions do not surrender lightly. Through stories and conversations, I absorbed some vague knowledge about the scholars of old and longed to write and paint as masterfully as they did. But we had no brushes in the house, no ink, virtually no paper. Although I do not remember the details, I had heard somewhere that, in the past, students practiced writing with a heavy brush and viscous ink as a means of strengthening the hand and control of the brush. With this in mind, I made myself a brush out of a metal pipe and pig bristles. I put sand in the pipe's barrel to make the brush even heavier. It must have weighed several pounds. In this way I taught myself calligraphy, writing on a large brick with "ink" made from thick yellow earth mixed with water. Even after the Cultural Revolution subsided and teachers were again available, I continued a habit of self-study. Museums, books and the natural world became my teachers.

(2002)

Plate 16
Wang Mansheng, Study of Buddist Figures, 17 x 14 inches, wood cut print on canvas, 2004

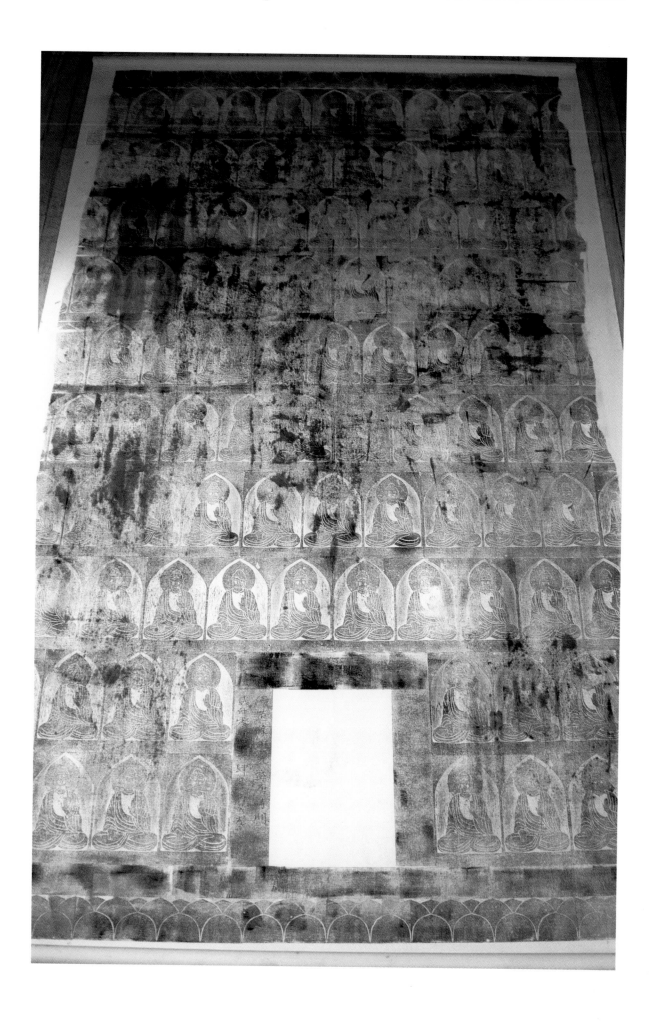

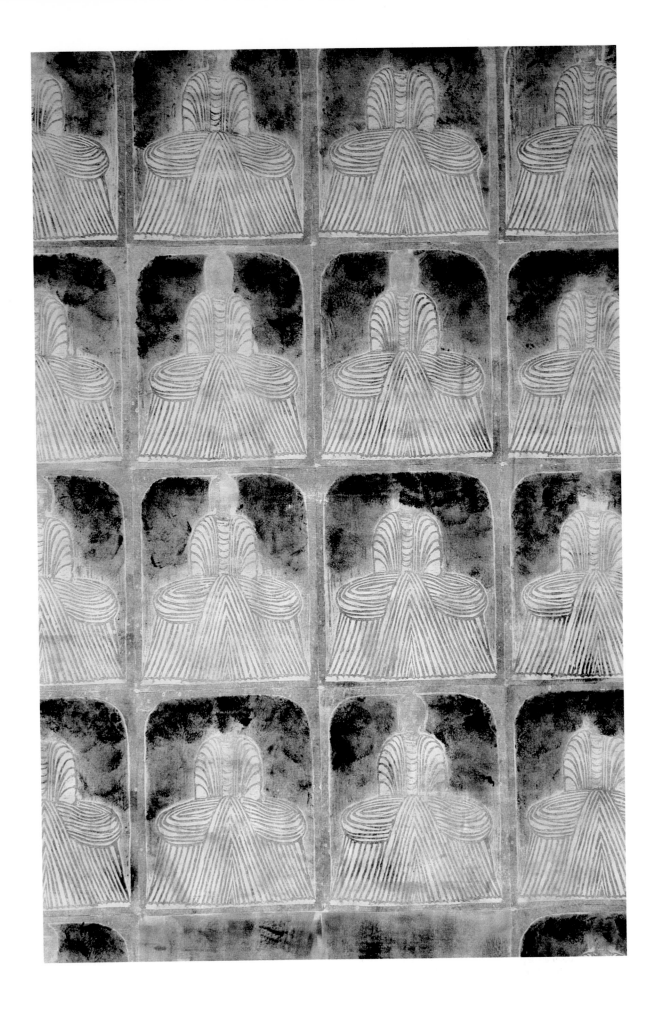

60

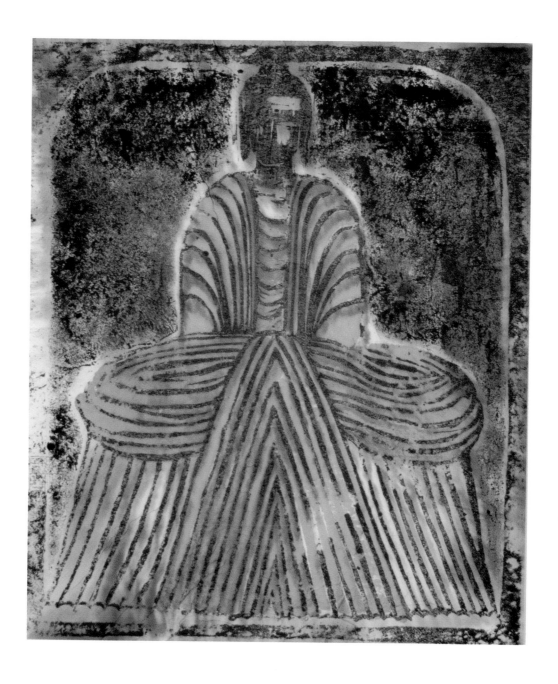

Plate 17
Wang Mansheng, Study of Buddist Figures,
detail, 17 x 14 inches, wood cut print on
canvas, 2004

Plate 18
Wang Mansheng, Study of Buddist Figures,
detail, wood cut print on paper, 2004

Wang Wu

Wang Mansheng

I first heard about the Wang Wu Mountains when we were studying the quotations of Chairman Mao in school. Mao used the ancient story from Liezi, the Foolish Old Man Who Moved the Mountains, as a way of encouraging the Chinese people to raze the two mountains of feudalism and imperialism.

The story fascinated me. Its reference to the Tai Hang Mountains was familiar since those mountains were close to the city where I lived. The Wang Wu Mountains, however, were near the southern part of Shanxi Province on the Henan border and I'd never been there. Wang Wu means King's House. Wang, the word for king, is also my surname. I'd never heard of any mountains with a name like this. A house for a king. A house for a Wang. My house. What were the mountains really like?

A geography book I later read about Wang Wu said that the shape of the mountains resembled a king's house, with three levels – deep valleys and caves, rolling hills, tall peaks. It described paths steep and winding, with Daoist belvederes and temples scattered like stars, like pieces on a chessboard, throughout.

Lie Zi was Lie Yukou, from the state of Zheng during the Warring States period. The dates of his birth and death are unknown, but the *Book of Han* records indicate that Lie authored the Liezi, but the original was lost. Most people believe the extant text was written during the Wei-Jin period. Most people believe the extant text was written during the Wei-Jin period. The style and content of the book are similar to the writings of Lao Zi and Zhuang Zi, but the book also incorporates Buddhist ideas. Its eight chapters are filled with strange popular fables and legends. With no limits to the imagination, the stories can span a million years, the events can happen a million miles away. They describe the gigantic and the minute, the wise and the stupid, the eternal and the momentary. They startle and amaze. After reading the *Liezi*, Wang Wu took on more meaning.

Landscapes are a significant part of traditional Chinese painting and I've always been interested in studying the techniques used in the landscapes of old masters. Last year I took a trip to the southwestern United States. The textures, colors and shapes of the mountains there startled and amazed me. They were like something out of fables and legends. The experience pushed me to do a series of landscapes using traditional Chinese techniques and materials. The real landscapes mixed with those in my mind. I have named the series Wang Wu, filling in the spaces I imagined as a child.

(April 2004)

太形王屋二山方七百里高萬仞本在冀州之南河
陽之北北山愚公者年且九十面山而居懲山北之塞出
入之迂也聚室而謀曰吾与汝畢力平險指通豫南達
于漢陰可乎雜然相許其妻獻疑曰君之力曾不能
損魁父之丘如太行王屋何且焉置土石雜曰投諸渤海
之尾隱土之北遂率子孫荷擔者三夫叩石墾壤箕畚
運于渤海之尾鄰人京城氏之孀妻有遺男始齓跳
往助之寒暑易節始一反焉河曲智叟笑而止之曰
甚矣汝之不惠以殘年餘力曾不能毀山之一毛其如
土石何北山愚公長息曰汝心之固固不可徹曾不君婿
妻弱子雖我之死有子存焉子又生孫孫又生子子又有
子子又有孫子孫孫無窮匱也而山不加增何苦而不
平河曲智叟亡以應操蛇之神聞之懼其不已也告之
於帝帝感其誠命夸蛾氏二子負二山一厝朔東一厝雍
南自此冀之南漢之陰無隴斷焉

列子湯問第五

Plate 19
Wang Mansheng, Wang Wu Series,
28 x 22 inches, ink on paper, 2003

63

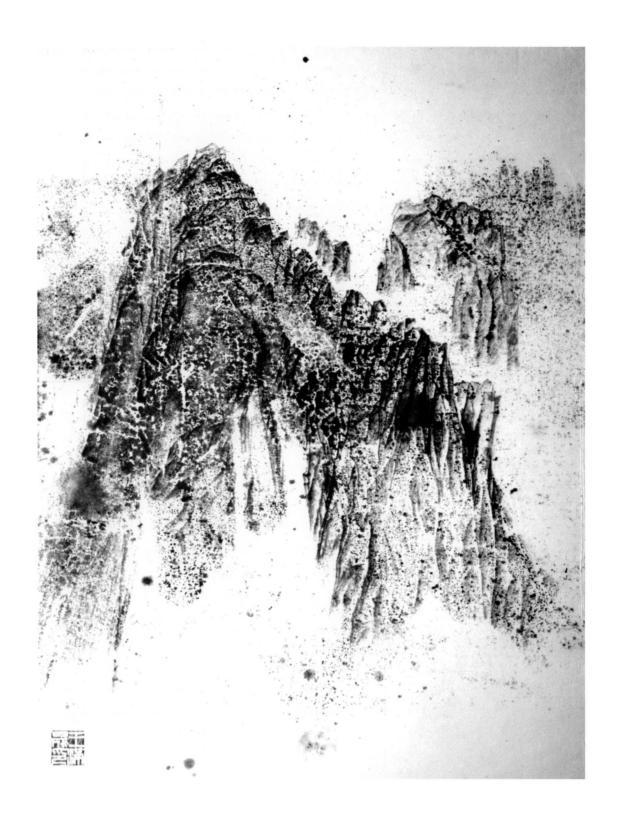

Plate 20
Wang Mansheng, Wang Wu Series,
28 x 22 inches, ink on paper, 2003

64

The Foolish Old Man Who Moved the Mountains

From Liezi, *Tang Wen 5*

[Translation by Wang Mansheng and Helena Kolenda]

The two mountain ranges Tai Hang and Wang Wu covered 700 square *li* and towered tens of thousands of feet high. They originally were south of Jizhou and north of Heyang. A foolish old man of North Mountain, 90 years of age, faced the peaks and was troubled that they blocked the way. To come and go, he had to go around them. He called his family together to confer and said, "Let's exert all our strength to level them so we can go straight to Yu'nan and get to Hanyin, alright?" All were in agreement. His wife, doubtful, asked, "With your strength, you couldn't even do damage to a hill of Kuifu. How can you manage Tai Hang and Wang Wu? And where will you put the earth and stones?" Everyone responded, "We'll throw it into the far reaches of the Bohai Sea north of Yintu." So he led his three sons and grandsons who could shoulder the carrying poles. They pounded and dug, scooped and shoveled, and carried the earth and stones to the far reaches of the Bohai Sea. The son of Jingcheng's widow, who had just lost his baby teeth, leapt to help them. Winter turned to summer before one trip was completed. An old wise man of Hequ, laughing, stopped the foolish old man and said, "You are really stupid. With the strength remaining at your age you can't even hurt one hair of the mountains. What will you do with the rocks and dirt?" The foolish old man of North Mountain gave a long sigh and said, "Your mind is so set you cannot open it. The widow and her small son are more enlightened. Even if I die, there are still my sons. My sons will have grandsons and the grandsons will have sons. Their sons will have sons and grandsons. There will be no lack of sons and grandsons. And the mountains will not get bigger. Why be concerned that they cannot be leveled?" The wise man from Hequ was at a loss for words. The serpent-wielding spirit of the mountains heard this. It was afraid the foolish old man wouldn't give up and told the spirit lord. The lord was moved by the foolish old man's resolve and ordered Kuaìe's two sons to carry the two mountain ranges away, one to Sudong and one to Yongnan. From then on, there were no obstructions south of Ji and north of Han.

(April 2004)

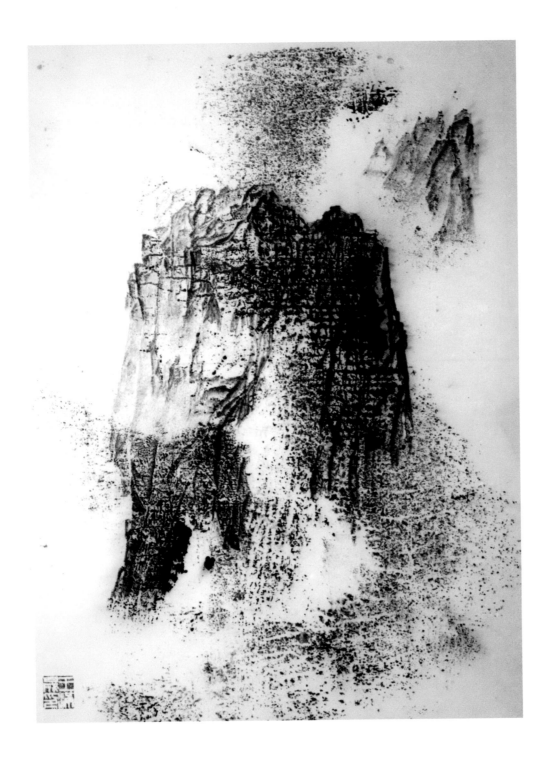

Plate 21
Wang Mansheng, Wang Wu Series,
28 x 22 inches, ink on paper, 2003

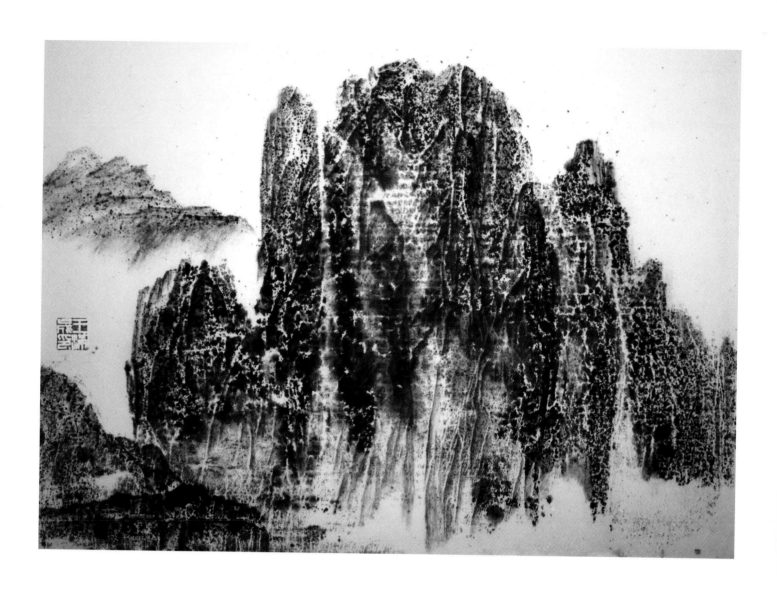

Plate 22
Wang Mansheng, Wang Wu Series,
28 x 22 inches, ink on paper, 2003

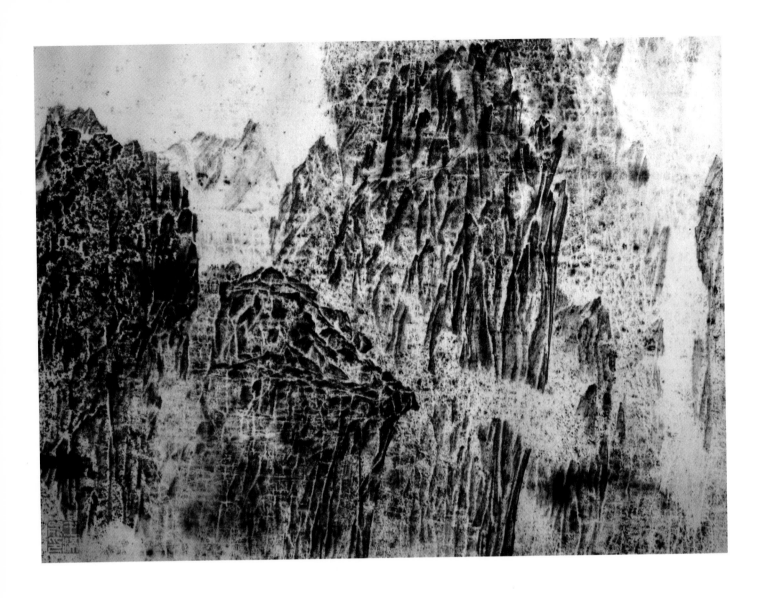

Plate 23
Wang Mansheng, Wang Wu Series,
28 x 22 inches, ink on paper, 2003

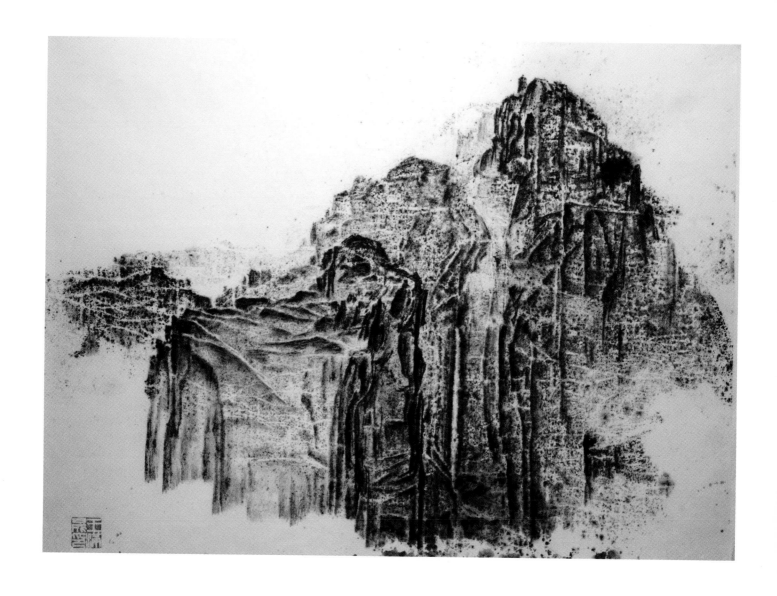

Plate 24
Wang Mansheng, Wang Wu Series,
28 x 22 inches, ink on paper, 2003

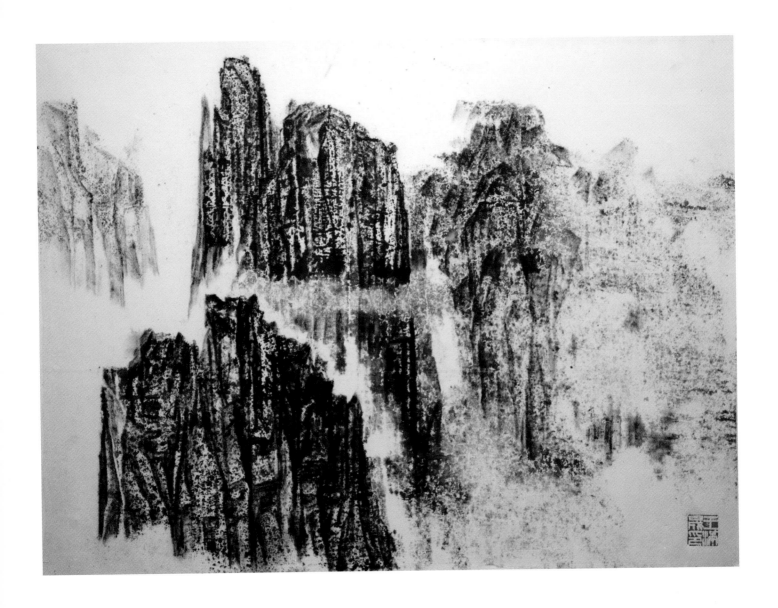

Plate 25
Wang Mansheng, Wang Wu Series,
28 x 22 inches, ink on paper, 2003

Xu Bing

Xu Bing's work presented in this exhibition is a selection from the works described below. Text provided by Xu Bing.

A Space for Square Word Calligraphy

Mixed media installation: Calligraphic works, Chinese brush, rice paper, ink

In the center of the exhibition space is displayed a monumental wall scroll featuring quotations from Chairman Mao on the concept of "art for the masses" inscribed in Xu Bing's invented "Square Word Calligraphy." There is also an area for practicing calligraphy, containing brushes, ink, paper, ink-stones and writing tables. The audience is invited to make use of these implements to write their own calligraphy using the Square Word format. The calligraphic works created by the audience are then exhibited on the walls in a constantly changing display. The pleasure and excitement felt by audience members in seeing their works formally exhibited in the gallery have the effect of altering their perception of their relationship to art.

Plate 26
Xu Bing, English Translation of Mao's Article in Square Word Calligraphy, ink on paper, 2001

An Introduction to New English Calligraphy
Mixed media installation: desk/chair sets, copy and tracing books, brushes, ink, video.

The intention of this installation is to simulate a classroom-like setting in a gallery or museum space. Desks are arranged with small containers of ink, brushes and a copybook with instructions on the basic principles of "New English Calligraphy," a writing system invented and designed by the artist. A video produced by Xu and entitled "Elementary Square Word Calligraphy Instruction," is played on a monitor in the exhibition space, capturing the audience's attention and inviting them to participate in the "class." Once they are seated at the desks, the audience is instructed to take up their brushes and the lesson in New English Calligraphy begins.

Essentially, New English Calligraphy is a fusion of written English and written Chinese. The letters of an English word are slightly altered and arranged in a square word format so that the word takes on the ostensible form of a Chinese character, yet remains legible to the English reader. As people attempt to recognize and write these words, some of the thinking patterns that have been ingrained in them since they learned to read are challenged. It is the artists' belief that people must have their routine thinking attacked in this way. While undergoing this process of estrangement and re-familiarization with one's written language, the audience is reminded that the sensation of distance between other systems of language and one's own is largely self-induced.

Plate 27
Xu Bing, Square Word Calligraphy classroom, mixed media interactive installation: desks, chairs, copy and tracing books, brushes, ink, and video, 1994-1996

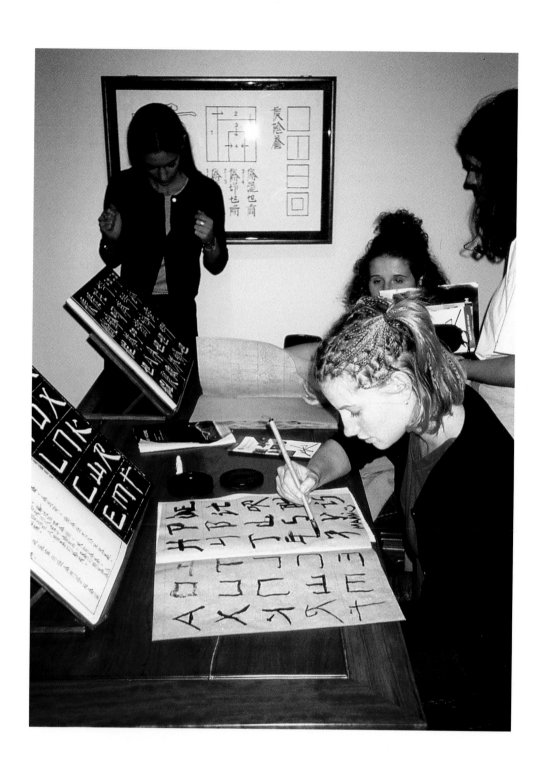

Plate 28
Xu Bing, A block of non-readable
Square Words, wood

Plate 29
Xu Bing, A block used to print "A Book
from the Sky", wood

Plate 30
Xu Bing, Practice Square Word
Calligraphy in a Traditional Format of
Textbook and Notebook, ink on paper

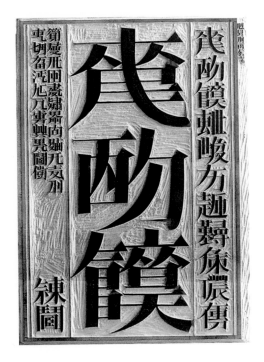

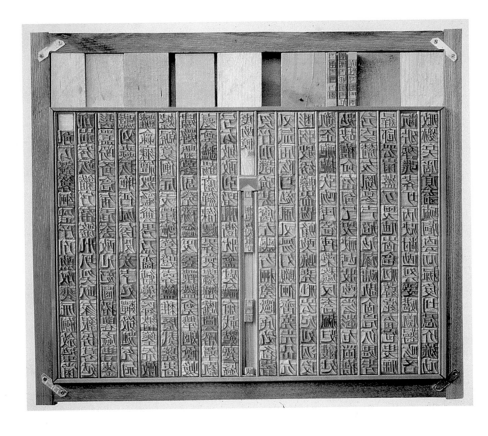

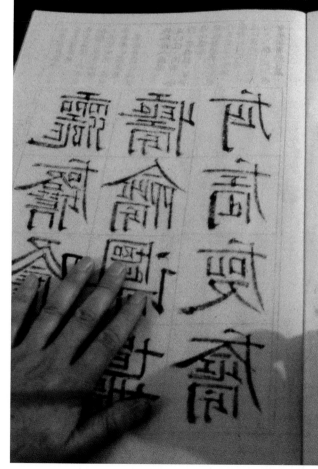

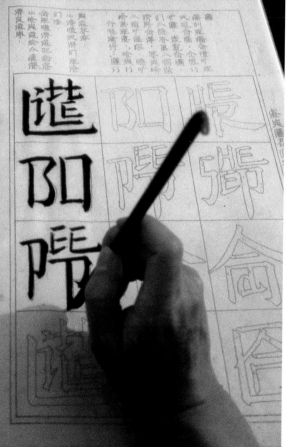

Your Surname Please
Mixed media installation: panels of calligraphy, computers, printers, desks and chairs

In this interactive computer installation, three computer stations are installed below a display of large wall panels on which various surnames have been inscribed in Xu's invented "New English Square Word Calligraphy." Audience members are invited to sit at one of the stations and type their own surnames out in standard English on the keyboard. The computer then processes this information, "transposing" their surnames into the New English Square Word Calligraphy and printing them out for the audience to take away. In this way the audience experiences a new and intriguing sense of personal connection with Chinese calligraphy.

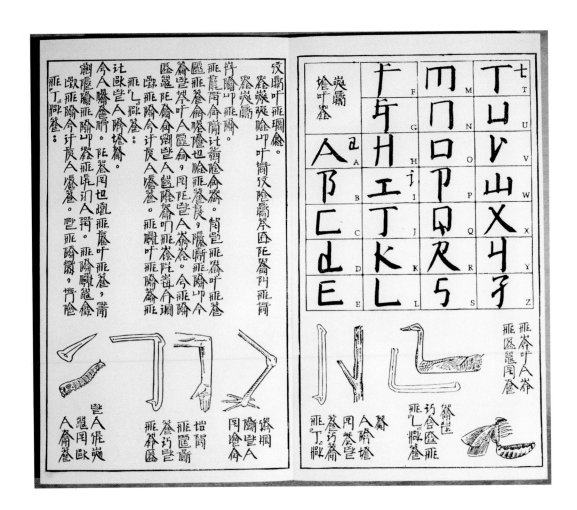

Plate 34
Xu Bing, Square Word Calligraphy
Textbook, paper

Plate 35
Xu Bing, Square Word written in the form
of a student paper corrected by a teacher
in red pen, ink on paper

The Living Word
Mixed-media installation: carved acrylic characters, paint

This installation was created for the exhibition "Word Play: Contemporary Art by Xu Bing" at the Arthur M. Sackler Gallery at the Smithsonian Institution in Washington, D.C., 2001.

The work is mainly comprised of over 400 calligraphic variants of the Chinese character niao, meaning bird, carved in colored acrylic and laid out in a shimmering track that rises from the floor into the air. On the gallery floor Chinese characters in the "simplified style" script popularized during the Mao era are used to write out the dictionary definition for niao or bird. The niao characters then break away from the confines of the literal definition and take flight through the installation space. As they rise into the air, the characters "de-evolve" from the simplified system to standardized Chinese text and finally to the ancient Chinese pictograph based upon a bird's actual appearance. At the uppermost point of the installation, a flock of these ancient characters, in form both bird and word, soar high into the rafters toward the upper windows of the space, as though attempting to break free of the words with which humans attempt to categorize and define them.

The colorful, shimmering imagery of the installation imparts a magical, fairy-tale like quality. Yet the overt simplicity, charm and ready comprehensibility of the work has the underlying effect of guiding the audience to open up the "cognitive space" of their minds to the implications of, and relationships between, word, concept, symbol and image. From another perspective, in its use of ancient Chinese pictographs to explore the relationship between conceptual signs and natural objects, the work invites provocative comparisons to one of the most seminal works of Western conceptualism, Joseph Kousth's *Three Chairs*; and in so doing, points to fundamental differences at the root of these two civilizations.

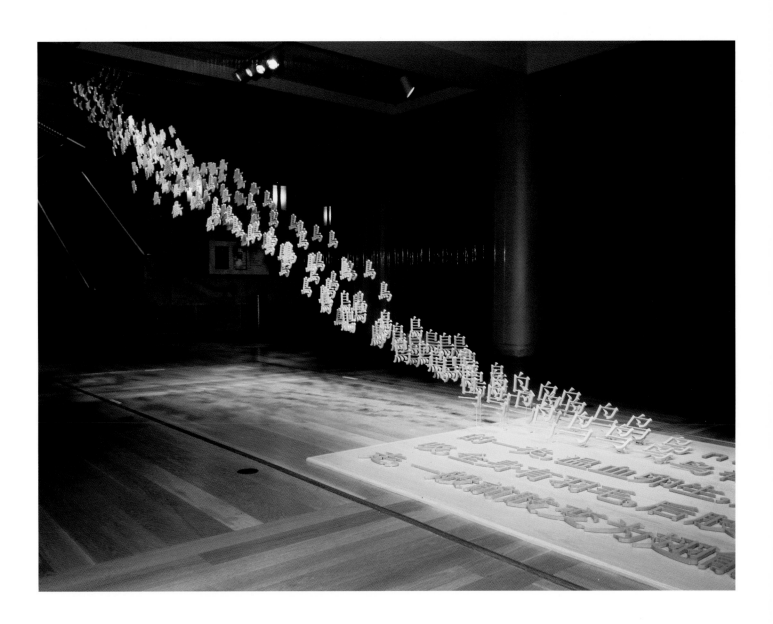

Plate 36
Xu Bing, The Living Word, installation of
carved acrylic characters and paint, Arthur
M. Sackler Gallery of the Smithsonian
Institution, Washington DC, 2001

Air Memorial
Glass, 2003

Air Memorial is a glass bubble containing air from Beijing during
the height of the SARS epidemic. On the surface of the capsule
is inscribed, "Beijing Air, April 27, 2003," the day that the greatest
number of SARS related deaths were reported in Beijing, the artist's
hometown.

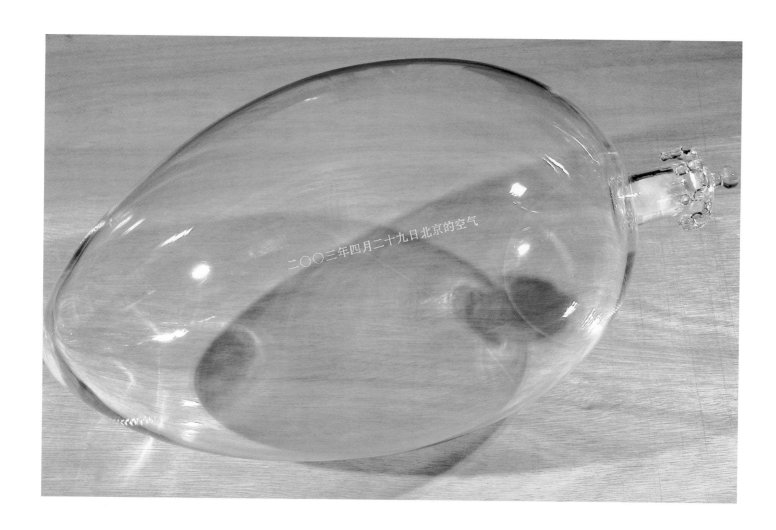

二〇〇三年四月二十九日北京的空气

Plate 37
Xu Bing, Air Memorial, a glass bubble
containing air from Beijing during the
height of the SARS epidemic, 2003

Where the Dust Itself Collects?
Dust, scaffolding and photograph, 2004

Xu Bing has made a new installation using dust collected in the aftermath of September 11th, 2001 when the World Trade Centre collapsed. He makes reference to how lower Manhattan became covered with a fine whitish-grey film. The outline of a Zen Buddhist poem is visible, revealed as if letters have been removed from under the dust layer:

The Bodhi (True Wisdom) is not like the tree;
The mirror bright is nowhere shining;
As there is nothing from the first,
Where does the dust itself collect?

This was written as the true expression of Zen faith by Hui-neng (638-713), traditionally considered the Sixth Patriarch of the Zen sect in China and therefore a much revered figure. In turn it was written in response to another poem by a Zen monk who claimed to understand the faith in all its purity:

The body is the Bodhi tree;
The soul is like the mirror bright,
Take heed to keep it always clean,
And let no dust collect upon it.

In the work Xu Bing discusses the relationship between the material world and the spiritual world, and the complicated circumstances created by different world perspectives. He collected the dust a few streets away from the devastated site and made it into a small figure in order to carry it through customs and thus to other places.

Xu Bing received the first Arts Mund Award for International Contemporary Art by this project in 2004.

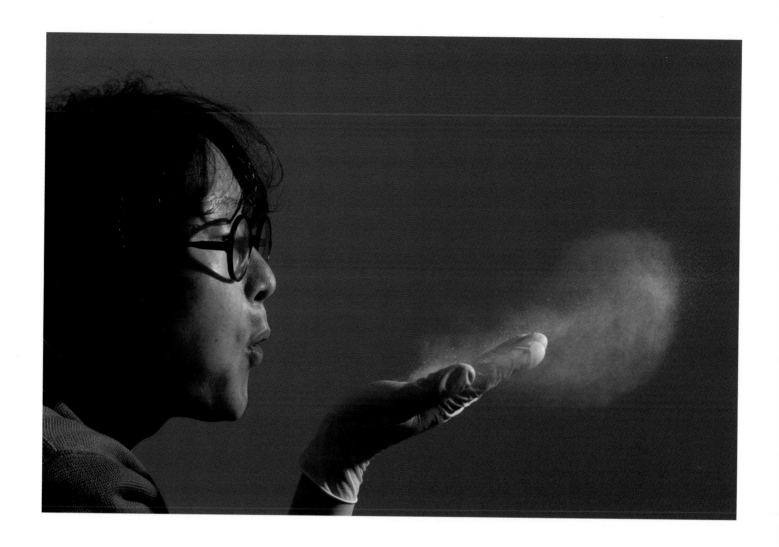

Plate 38
Xu Bing, Where the Dust Itself Collects?,
Dust, scaffolding and photograph, 2004

Zhang Hongtu

Selected Notes on *Recreating Shanshui Painting Project*
Zhang Hongtu
[Translated by Wang Ying and Zhang Hongtu]

My ongoing series of oil paintings "Recreating *Shanshui* Painting" began in 1998. This project means to use the methods of Impressionism and Post-Impressionism, such as the works of Monet, Van Goth, and Cézanne, to reproduce and enhance the *shanshui* paintings of ancient Chinese masters. For example, I use the color and resolution of light developed by Monet to copy Zhao Mengfu's "Autumn Color of *Que* and *Hua* Mountains", or I take the brushstrokes and colors of Van Gogh to alter the unique dots and lines of Shitao. I intend to twist two different things together, East and West, with or without ease of balance. During this process, I, myself, am trying to become an invisible third person. I intentionally hide myself and do not show my own taste in colors nor my habits of brushstrokes. I, the one who is actually handling the brushes, believe that what I myself am showing on canvas is only a concept.

Ancient Chinese artists wrote poems on their paintings and gave poetic titles to their works. Many of these titles and poetry describe the reflection of light in nature and they turned into Impressionist images in my mind. Scholars would tell me that making such a linkage is a misunderstanding. They may be right. However, I cannot help making these connections to Impressionist painting whenever I read these Chinese words. If "correctly understanding art" has become the absolute standard for art studies, I'd rather be marching to the tune of the misunderstood.

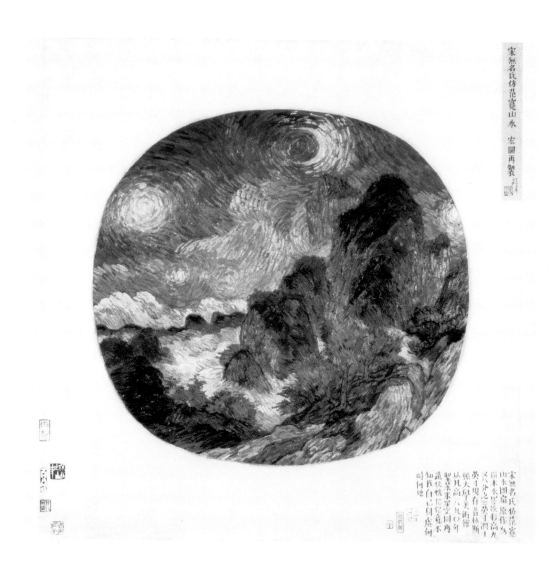

Plate 39
Zhang Hongtu, Anonymous (Song
Dynasty)—van Gogh, 48 x 48 inches, oil
on canvas, 2002-2003, private collection,
New York

For a long time, ancient Chinese painting did not move me visually. I could not find the elements there that stimulate my visualization. I cannot see brilliant colors, I cannot find the lines and brushstrokes of passion, nor any images related to my life. I understand the magnificence of these works through an art historical point of view, but I have no way to enjoy them directly as ancient Chinese people did. The biggest difficulty is to see past without the lenses of today, and see them in their original perspective. When I look at them, I am reminded of a totally different perspective, my own.

On the other hand, the freedom those ancient Chinese artists held regarding the creation they absorbed was beyond the imagination of their contemporary European colleagues. The concept of *shanshui* in ancient China evolved from its very beginnings. Chinese artists had no need to record the real world outside their window. Instead, they put together whatever they found interesting, in order to rearrange nature and to create a multi-perspective world. Multi-perspective is a modern term. Ancient artists perhaps did not think in that way. Ancient Chinese people treat *shanshui* as an individual art piece, not as a record of a particular location or the memory of an actual image. Right now, for instance, I am reading/looking at a *shanshui* volume of Gong Xian's works, a collection stored in the National Museum in the Forbidden City in Beijing. I cannot find what appears to be actual mountains or river, or trees nor grass. What I can see is rows of black ink dots and columns of ink lines. I feel the ink to be moving and changing on the paper in its own way, freely. In fact, the language of Gong Xian is so pure that it is relevant even now.

A good piece of artwork is not only a record of its time and society, but contains high-quality artistic language. No matter what nationality you are, your eyes enjoy color and recognize shape. If the visual stimulation of a painting first and directly goes to the audience's retina, I would consider that Monet, van Gogh and Cezanne's works were a milestone in art history. The color of their works came from nature; even the ones painted with strong personal emotion such as van Gogh's, or the carefully arranged colors, form, and structure of a painting such as Cezanne's. All of these artists painted from life. They were all honest to their natural feelings. If these artists' retinas

Plate 40
Zhang Hongtu, Dong Qichang-Cezanne,
2, 78 x 36 inches, oil on canvas, 1999

92

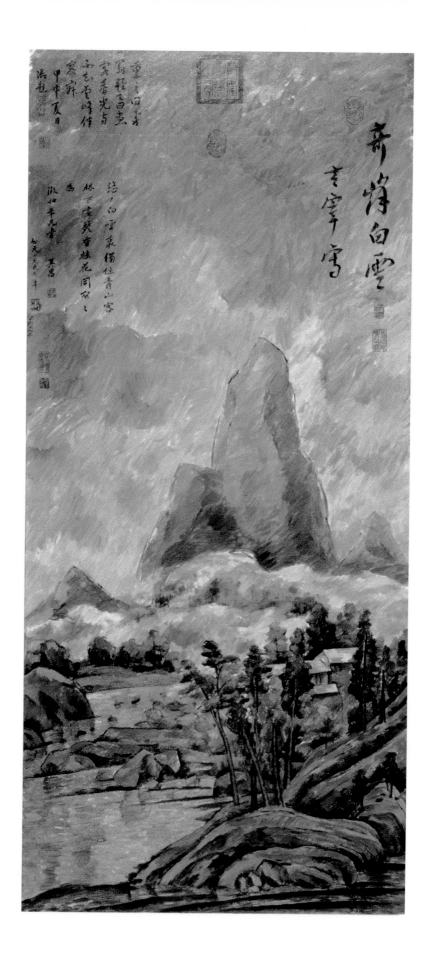

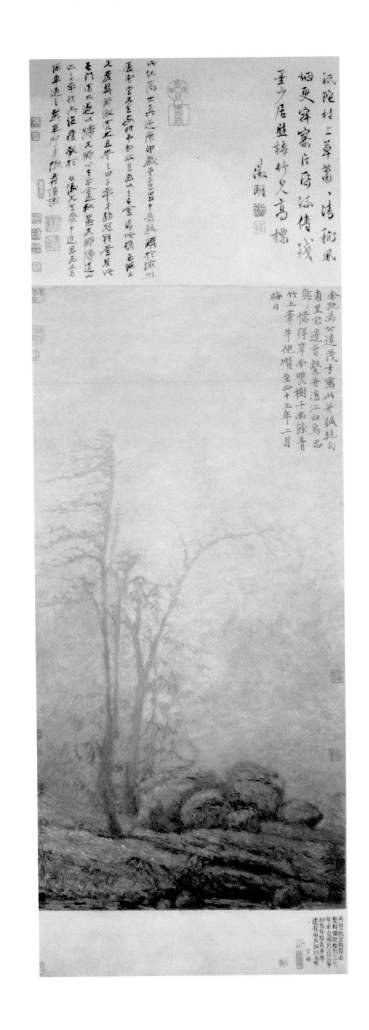

祇陀村上草菴、清颷風
烟更宜安寨片屠綠傳竣
亞少居騷转竹見高標

　　徵明

余既為分遠茂才寓此并驪鼫句
甫里宅逵曾數系舟滄江白鳥思
惣惺得峯南雙樹千雨餘青
竹上牽牛㑷瀆至四十三年二月
晦日

can be satisfied by the colors on their canvas, others' retinas would be satisfied too. It's because no matter what one's ethnic and culture background, regardless of whether one has "double-folded eyelids" or "single-folded eyelids," or adds a fold with surgery, the essential ability of all human eyes is simply to perceive the world. This ability is forever the same. The common function of human eyes determines the commonality of visual art. Therefore, I consider that the colors of the Impressionists and Post-Impressionists indicate a visual value that can be accepted by people everywhere.

Chinese *shanshui* goes to another extreme in that it is not concerned with the visual result of color and light, but is near to what we call "concept art" today. When Chinese artists rearrange nature on paper and make it, in fact, into an unnatural world, and reduce colors to black and white, their paintings represent a concept, a spirit, instead of merely being a pleasure for the retina.

Ancient Chinese painting is anti-color and thus marches toward conceptual art. I think it is a lot of fun to twist these two things together for the two schools contain such a clear contrast: Chinese artists make up mountains and water in their hearts and mind behind a closed door, while Impressionist/Post-Impressionists draw nature directly outdoors under the burning sunshine. One abandons all that may stimulate physical pleasure, the other plays with colors for pure joys of the retina; one copies ancient masters and uses methods of the long-deceased to create his new works, the other tries to break through others' rules and establish a unique character of his own. Can anything be more interesting than to put these two styles twisted together?

Plate 41
Zhang Hongtu, Ni Zan–Monet, 96 x 34
inches, oil on canvas, 2002-2003

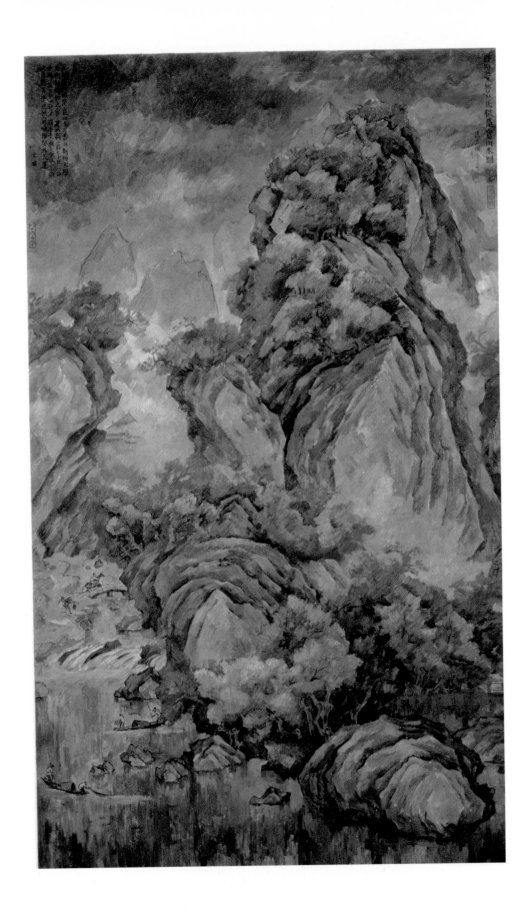

96

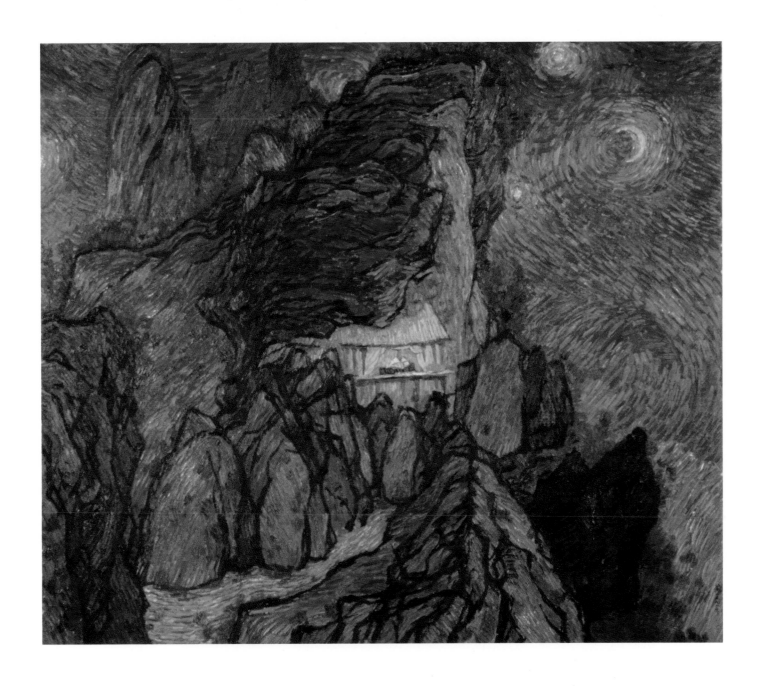

Plate 42
Zhang Hongtu, Anonymous (Yuan
Dynasty)-Cezanne, 86 x 52 inches,
oil on canvas, 2003

Plate 43
Zhang Hongtu, Shitao–van Gogh,
58 x 68 inches, oil on canvas, 1998

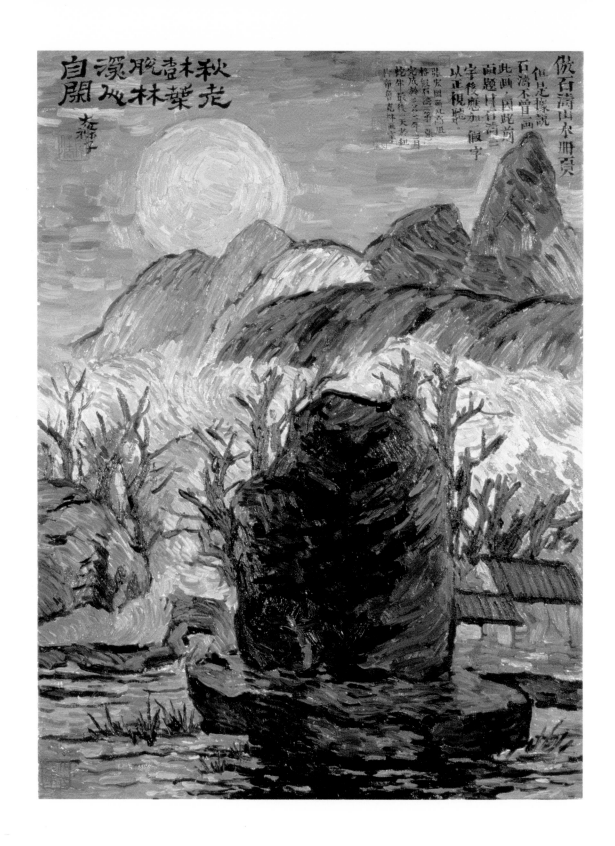

Plate 44
Zhang Hongtu, Shitao (Album)-van Gogh,
48 x 36 inches, oil on canvas, 2002

98

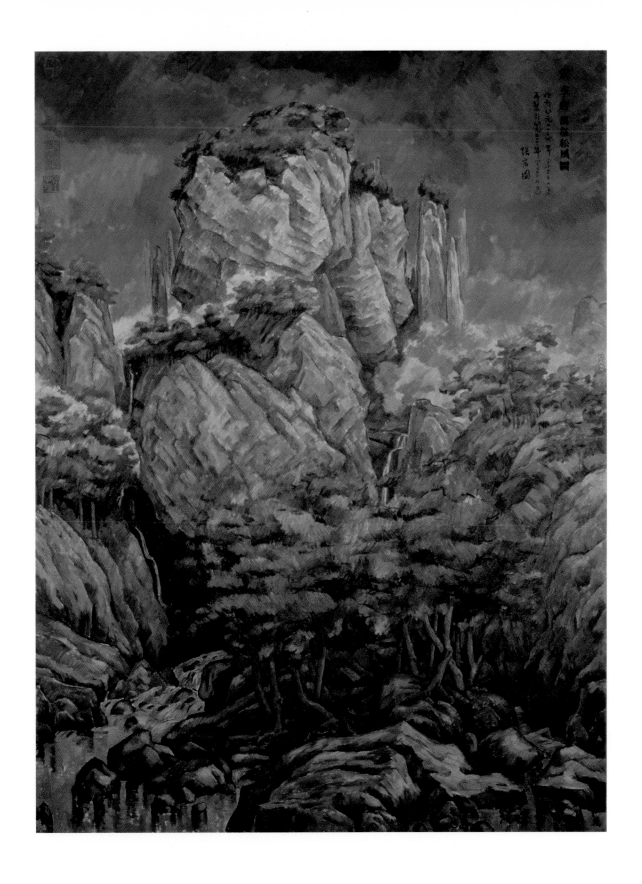

Plate 45
Zhang Hongtu, Li Tang-Cezanne,
96 x 72 inches, oil on canvas, 2001

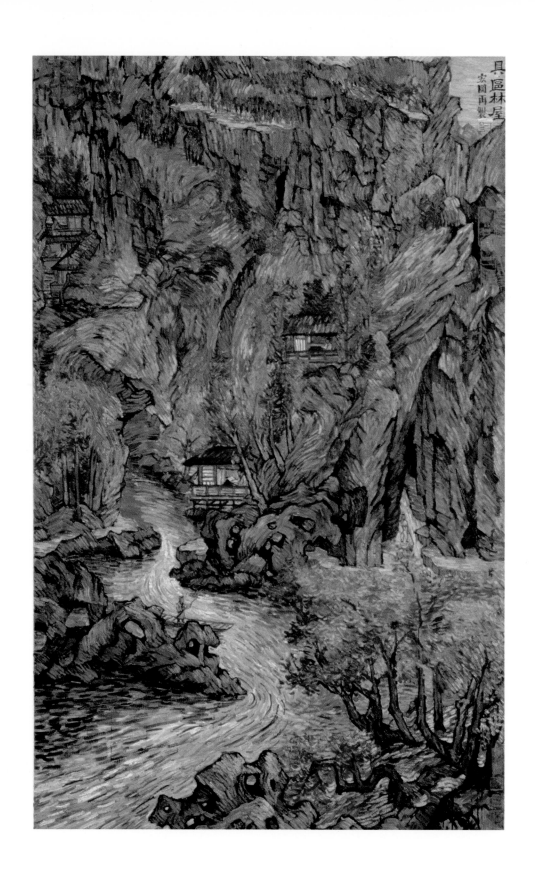

Plate 46
Zhang Hongtu, Wang Meng–van Gogh,
70 x 48 inches, oil on canvas, 2003-2004

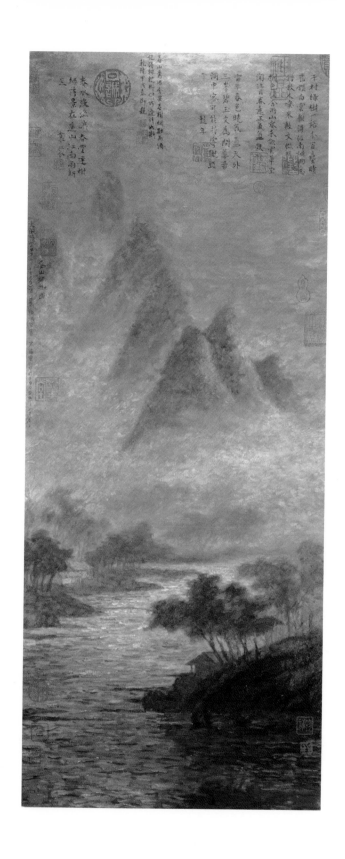

Plate 47
Zhang Hongtu, Wen Zhengming-Monet,
96 x 40 inches, oil on canvas, 1999,
private collection

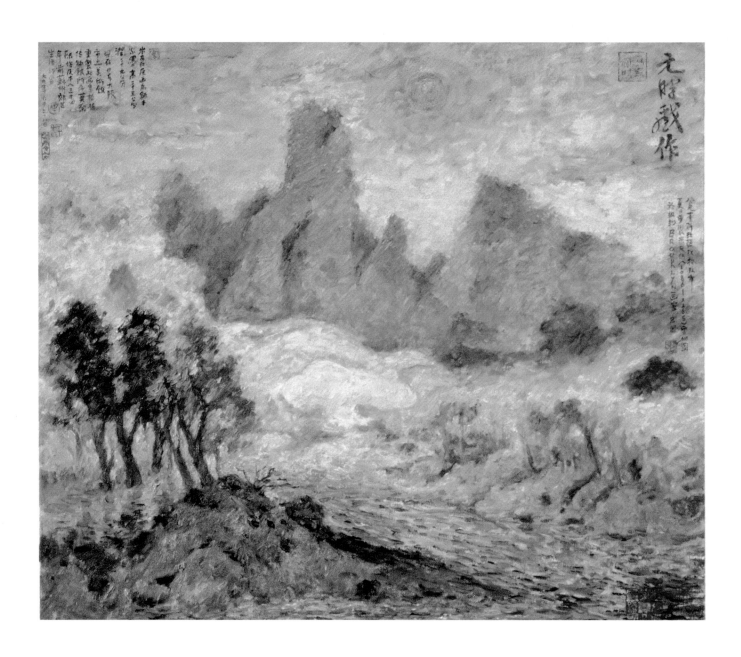

Plate 48
Zhang Hongtu, Mi Youren–Monet,
44 x 52 inches, oil on canvas, 1999

Plate 49
Zhang Hongtu, Fan Kuan-van Gogh
2, 96 x 40 inches, oil on canvas,
2002, collection of Peter Norton Family
Foundation

仿范寬溪山行旅圖

張宏圖二〇〇二馬年夏日

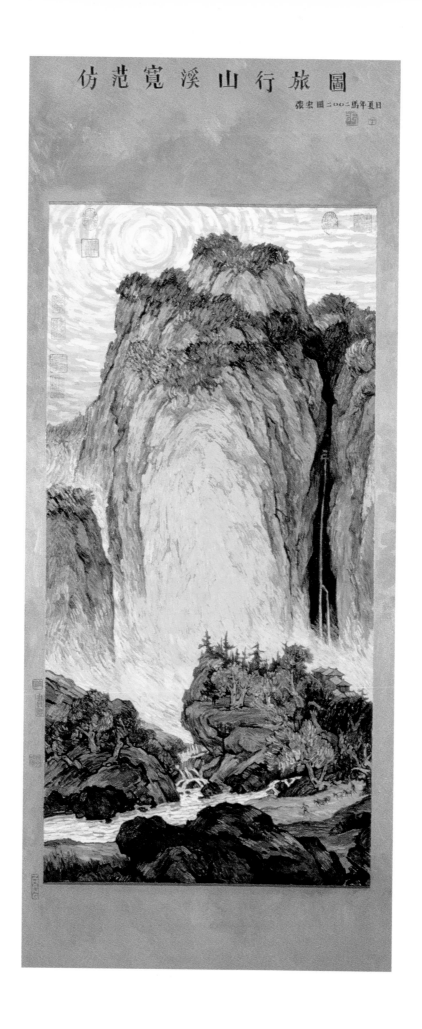

Endnotes

[1] All names are given in their Chinese form: Chinese names are made up of family name, which is always placed first, and then the given name. The names of Wang Mansheng, Xu Bing, and Zhang Hongtu follow this Chinese form. Gu Wenda is more commonly known as Wenda Gu in accordance with American custom. Of the two curators, Wang Ying's is in Chinese form and Yan Sun's follows American.

[2] There are 56 ethnic groups in China. The Han people are majorities.

[3] China, Soviet Union and other soviet countries named themselves as socialist, not communist.

[4] From Xu Bing's lecture at the University of Wisconsin-Milwaukee on October 7th 2003.

[5] From E-mail correspondence with the artist, June 2004

[6] From E-mail correspondence with the artist, June 2004.

[7] The discussion of Buddhism refers to all versions that are practiced in India and China. Its content and principle in Japan, for example, might be different.

[8] Caterforis, David. "Interview with Wenda Gu." *Wenda Gu: Art from Middle Kingdom to Biological Millennium.* Edited by Mark H.C. Bessire. (Cambridge, Massachusetts: MIT Press, 2003): 149.

[9] *Wenda Gu: Art from Middle Kingdom to Biological Millennium*, 37.

[10] *Art and Feminism*, eds. Helena Reckitt and Peggy Phelan (New York: Phaidon Press): 162.

[11] Kristeva, Julia. *Powers of Horror: An Essay on Abjection* (New York: Columbia University Press, 1980): 10.

[12] *Wenda Gu: Art from Middle Kingdom to Biological Millennium*, 34.

[13] Kristeva, 13.

[14] Kristeva, 10.

[15] *Wenda Gu: Art from Middle Kingdom to Biological Millennium*, 34.

[16] Minghu, Gao. "Seeking a New Model of Universalism." *Wenda Gu: Art from Middle Kingdom to Biological Millennium*, 22.

[17] Kristeva, 18.

[18] *Wenda Gu: Art from Middle Kingdom to Biological Millennium*, 35.

[19] Leung, Simon and Janet Kaplan. "Pseudo-Languages: A Conversation with Wenda Gu, Xu Bing, and Jonathan Hay." *Art Journal*, v. 58 Issue 3 (Fall 1999): 86.

[20] Kristeva, 4.

[21] Leung, Simon and Janet Kaplan. "Pseudo-Languages: A Conversation with Wenda Gu, Xu Bing, and Jonathan Hay," 86.

[22] Ibid.

[23] Ibid.

[24] Kristeva, 8.

[25] Caterforis, David. "Interview with Wenda Gu." Wenda Gu: Art from Middle Kingdom to Biological Millennium, 149.

[26] Lippard, Lucy. The Lure of the Local: The Sense of Place in a Multi-centered Society. (New York: New Press, 1997): 9.

[27] Leung, Simon and Janet Kaplan. "Pseudo-Languages: A Conversation with Wenda Gu, Xu Bing, and Jonathan Hay," 86.

[28] Translator's note: In China, drawing can be interpreted as writing when the subjects are mountains and water. "Write" partially refers to using the brushwork of calligraphy when drawing.

[29] Yuan Jiang was a court painter of the Qing Dynasty, who was well known for his paintings of architectural structures in landscapes.

[30] Translation by Pauline Yu in "The Poetry of Retreat", Masterworks of Asian Literature in Comparative Perspective, M.E. Sharpe (1994).

Glossary of Terms in Chinese

Ajia	阿珈	a living Buddha
Bada Shanren	八大山人	artist of the Qing dynasty , ca.1626-1705
Bai Juyi	白居易	poet of the Tang dynasty, 772-846
Bansheng	搬生	
Baoding	保定	
bei	碑	stone stele
Bi Sheng	毕升	invented moveable blocks for print during the early part of 11th century
Caimohua xi	彩墨画系	the Department of Color and Ink
Cai Yuanpei	蔡元培	educator and scientist, 1868-1940
Cang Jie	仓颉	a legendary Chinese figure who created writing
Chan	禅	Japanese version known as Zen
chuan	川	a river
chuanghu	窗戶	window
Chong Yang Gong	重阳宫	a Daoist temple at Taiyuan
cunfa/tsunfa	皴法	a particular brushwork used in Chinese landscape
cundian	皴點	brush dots used in Chinese painting
Dalai	达赖	the highest living Buddha
da zi bao	大字报	papers written in large sized words
Daojia	道家	Daoism/Taoism, a Chinese philosophy
Dong Qichang	董其昌	artist, art critic and prime Minister of the Ming Dynasty, 1555-1636
Dunhuang	敦煌	Buddhist grottos in Gansu province
Fan Kuan	范宽	*shanshui* artist of the Song Dynasty, active ca.1023-1031.
fengjinghua	风景画	landscape painting
fengshui	风水	wind and water, Chinese geomancy
Fu Shan	傅山	artist of the Qing Dynasty, 1606-1684
Fudan	复旦	a university at Shanghai
Gong Xian	龚贤	artist of the Qing Dynasty, 1618-1689
Gu Wenda	谷文达	
Guo Xi	郭熙	artist of the Song dynasty, ca.1020-1090
Henan	河南	
Hua Chan Shi Suibi	画禅室随笔	Essay on the Studio Painting of Chan
Huai	淮	the Huai River
Huang Qiuyuan	黄秋园	20th century artist
Jiayang	迦养	a living Buddha
Jieziyuan huapu	芥子园画譜	Garden of Mustard Seeds
Kang Youwei	康有为	scholar, writer, political figure of the late Qing Dynasty and early Republic, 1858-1927
Lie Zi	列子	philosopher, active in the later part of 5th century BCE
liu	柳	willow
Liu Haisu	刘海粟	artist, 1896-1994

Longmen Shiku	龙门石窟	Buddhist grottos at Luoyang, Henan
Lu Yanshao	陆颜少	artist of the 20th century
Lushan	庐山	a mountain in Jiangxi province
Mao	毛, 毛泽东	Mao, Mao Zedong, 1893-1976, founder of the People's Republic of China
mu	木	wood
Ni Zan, Ni Yunlin	倪瓒, 倪云林	artist of the Yuan Dynasty, 1301-1374.
Niangziguan	娘子关	an important fortress along the Great Wall
pianpang bushou	偏旁部首	radicals; the segments that compose Chinese written character
Qianlong	乾隆	an emperor of the Qing Dynasty, reigns 1736-1795
Qin Shi Huang Di	秦始皇帝	the first emperor of the Qin dynasty, late 3nd century BCE
Shaanxi	陕西	
shan	山	mountain
Shandong	山东	
Shanhaijing	山海经	the *Book of Mountains and Oceans*
Shangshu	尚书	the *Book of Documents*
shanshi	山水	mountains and water
shanshuihua zaizhi	山水画再制	Recreating *shanshui* Painting
Shanxi	山西	
Shen Zhou	沈周	artist of the Ming Dynasty, 1427-1509
shi	石	stone
shi shu hua yin	詩书画印	poetry, calligraphy, painting, and identifying-seal
Shitao	石涛	artist of the Qing Dynasty, ca.1642-1718
shu hua tong yuan	书画同源	painting and calligraphy sharing the same origin
shui	水	water
Sichuan	四川	
song	松	pine tree
Su Shi/Su Dongbo	苏轼/苏东坡	scholar of the Song Dynasty, 1036-1101
Taersi	塔尔寺	a temple in Qinghai
Tai Hu	太湖	
Taishan	泰山	Mount Tai
Taiyuan	太原	
tan	檀	sandalwood
Tianlongshan	天龙山	Buddhist grottos at Mt. Tianlong
Tianshu	天书	A Book from the Sky
Tianxia Datong	天下大同	All under the heaven living in equality and happiness
Wang Mansheng	王满晟	
wenren	文人	traditional Chinese scholar
wenren hua	文人画	painting of scholars
Wuxi	无锡	
Wu Zetian	武则天	Queen Wu of the Tang Dynasty, reigns 624-705
Xi'an	西安	
xinxiang	心像	images reflected in the heart
Xu Bing	徐冰	
Xu Zhou	徐州	
Yalong	雅龙	a river in Tibet
Xiaozhuan	小篆	writing style of the Qin from the 3rd century BCE
yijing	意境	poetic spiritual atmosphere, spirit/mood
Yuan Jiang	袁江	a court artist of the Qing Dynasty, active ca. 1680-1730
zaohua	造化	the true spirit of nature
Zhao Mengfu	赵孟頫	Yuan Dynasty artist, 1254-1322
Zhang Hongtu	张宏图	
Zhejiang	浙江	
Zhu Dongrun	朱东润	critic on classical Chinese literature of the 20th century
Zongkeba	宗喀巴	founder of the religious system of Tibetan Buddhism in the early15[th] century

List of Illustrations and Plates

Figure 1
Zhang Hongtu, Eternal Life,
33.5 x 63.5 inches, oil on canvas, 1980,
collection of the National Art Gallery,
Beijing

Figure 2
Xu Bing, A Book from the Sky, hand
printed on paper, National Gallery of
Canada, Ottawa,1998

Figure 3
Gu Wenda, Wisdom comes from
tranquility, multi-media, Lausanne, 1987

Figure 4
Landscape near Xi'an

Figure 5
Mines for the stone materials of
Gu Wenda's steles, near Xi'an

Figure 6
Craft worker carving inscriptions on the
Stele for Gu Wenda

Figure 7
Gu Wenda, A stone stele during its
carving

Figure 8
Crafts workers tapping the inscriptions
on stele

Figure 9
Xu Bing, Art for the People, fabric banner,
dye sublimation on dacron polyester, 9
x 36 feet, displayed at the Museum of
Modern Art in New York, 1999

Figure 10
Zhang Hongtu, Kekou Kele-Coco Cola,
9.75 x 2.85 inches, porcelain, 2002

Figure 11
Wang Mansehng, Study of Gong Xian
(Thoughts about Gong Xian's Paintngs),
ink on paper, 2003

Figure 12
Wang Mansheng, Study of Gong Xian,
8.5 x 11.5 inches, Ink on paper, 2003

Figure 13
Wang Mansheng, Study of Cizhou Ware,
14 x 11 inches, ink on paper, 2001

Figure 14a
Gu Wenda, china monument: temple of
heaven, human hair, wood, and digital
installations, 1998-2004

Figure 14b
Gu Wenda, china monument: temple of
heaven, detail

Figure 15
Gu Wenda, united nations series, detail,
1993-2004

Figure 16
Gu Wenda, united nations series, detail,
1993-2004

Figure 17
Wenda Gu, silent performance in
Hangzhou

Figure 18
Mansheng Wang in His Studio, 2003

Figure 19a
Photo of Xu Bing

Figure 19b
Photo of Xu Bing

Figure 20
Photo of Zhang Hongtu

Plate1
Gu Wenda, retranslation and rewriting of
Tang poetry, digital image

Plate 2
Gu Wenda, steles on display, stone,
75 x 44 x 8 inches each, 1993-2004

Plate 3
Gu Wenda, steles on display, stone,
75 x 44 x 8 inches each, 1993-2004

Plate 4
Gu Wenda, Introduction to Retranslation
and Rewriting of Tang Poetry, in Chinese

Plate 5
Gu Wenda, Introduction to Retranslation
and Rewriting of Tang Poetry, in Chinese

Plate 6
Gu Wenda, Poem of Chang Jian and Gu's
Translations

Plate 7
Gu Wenda, Poem of Liu Zongyuan and
Gu's Translations

Plate 8
Gu Wenda, Poem of Wang Bo, ink
tapping on paper, 71 x 38 inches

Plate 9
Gu Wenda, Poem of Wang Wei, ink
tapping on paper, 71 x 38 inches

Plate 10
Gu Wenda, Poem of Wei Yingwu, ink
tapping on paper, 71 x 38 inches

Plate 11
Gu Wenda, Poem of Jia Dao, ink tapping
on paper, 71 x 38 inches

Plate 12
Wang Mansheng, Study of Buddhist
Figures, 17 x 14 inches, ink on paper,
2004

Plate 13
Wang Mansheng, Lotus Pond in Deep
Autumn, 83 x 31.5 inches each panel, ink
and color on paper, 1998

Plate 14
Wang Mansheng, Lotus Pond in Deep
Autumn, left panel, 83 x 31.5 inches,
ink and color on paper, 1998

Plate 15
Wang Mansheng, Lotus Pond in Deep
Autumn, right panel, 83 x 31.5 inches,
ink and color on paper, 1998

Plate 16
Wang Mansheng, Study of Buddist
Figures, 17 x 14 inches, wood cut print
on canvas, 2004

Plate 17
Wang Mansheng, Study of Buddist
Figures, detail, ink on paper, 2004

Plate 18
Wang Mansheng, Study of Buddist
Figures, detail, wood cut print on
paper, 2004

Plate 19
Wang Mansheng, Wang Wu Series,
28 x 22 inches, ink on paper, 2003

Plate 20
Wang Mansheng, Wang Wu Series,
28 x 22 inches, ink on paper, 2003

Plate 21
Wang Mansheng, Wang Wu Series,
28 x 22 inches, ink on paper, 2003

Plate 22
Wang Mansheng, Wang Wu Series,
28 x 22 inches, ink on paper, 2003

Plate 23
Wang Mansheng, Wang Wu Series,
28 x 22 inches, ink on paper, 2003

Plate 24
Wang Mansheng, Wang Wu Series,
28 x 22 inches, ink on paper, 2003

Plate 25
Wang Mansheng, Wang Wu Series,
28 x 22 inches, ink on paper, 2003

Plate 26
Xu Bing, English Translation of Mao's
Article in Square Word Calligraohy, ink
on paper, 2001

Plate 27
Xu Bing, Square Word Calligraphy
classroom, mixed media interactive
installation: desks, chairs, copy
and tracing books, brushes, ink, and
video, 1994-1996

Plate 28
Xu Bing, A block of non-readable
square-words, wood

Plate 29
Xu Bing, A block used to print "A Book
from the Sky", wood

Plate 30
Xu Bing, Practice Square Word
Calligraphy in a Traditional Format of
Textbook and Notebook, ink on paper

Plate 31
Xu Bing, Square Word of Men in English,
digital print, 120 x 90 cm, 2003

Plate 32
Xu Bing, Square Word of Women in
English, digital print, 120 x 90 cm, 2003

Plate 33
Xu Bing, Square Word of Nursery in
English, digital print, 120 x 90 cm, 2003

Plate 34
Xu Bing, Square Word Calligraphy
Textbook, paper

Plate 35
Xu Bing, Square Word written in the form
of a student paper corrected by a teacher
in red pen, ink on paper

Plate 36
Xu Bing, The Living Word, installation of
carved acrylic characters and paint, Arthur
M. Sackler Gallery of the Smithsonian
Institution, Washington DC, 2001

Plate 37
Xu Bing, Air Memorial, a glass bubble
containing air from Beijing during the
height of the SARS epidemic, 2003

Plate 38
Xu Bing, Where the Dust Itself Collects?,
Dust, scaffolding and photograph, 2004

Plate 39
Zhang Hongtu, Anonymous (Song
Dynasty)–van Gogh, 48 x 48 inches, oil
on canvas, 2002-2003, private collection,
New York

Plate 40
Zhang Hongtu, Dong Qichang-Cezanne,
2, 78 x 36 inches, oil on canvas, 1999

Plate 41
Zhang Hongtu, Ni Zan–Monet, 96 x 34
inches, oil on canvas, 2002-2003

Plate 42
Zhang Hongtu, Anonymous (Yuan
Dynasty)-Cezanne, 86 x 52 inches,
oil on canvas, 2003

Plate 43
Zhang Hongtu, Shitao–van Gogh,
58 x 68 inches, oil on canvas, 1998

Plate 44
Zhang Hongtu, Shitao (Album)-van Gogh,
48 x 36 inches, oil on canvas, 2002

Plate 45
Zhang Hongtu, Li Tang-Cezanne,
96 x 72 inches, oil on canvas, 2001

Plate 46
Zhang Hongtu, Wang Meng–van Gogh,
70 x 48 inches, oil on canvas, 2003-2004

Plate 47
Zhang Hongtu, Wen Zhengming-Monet,
96 x 40 inches, oil on canvas, 1999,
private collection

Plate 48
Zhang Hongtu, Mi Youren–Monet,
44 x 52 inches, oil on canvas, 1999

Plate 49
Zhang Hongtu, Fan Kuan-van Gogh
2, 96 x 40 inches, oil on canvas,
2002, collection of Peter Norton Family
Foundation

gu wenda

wenda gu was born in 1955 in shanghai, graduated from the zhejiang academy of fine arts in 1981, lives and works in new york city since 1987.

selected personal & group exhibitions

wenda gu: from middle kingdom to biological millennium, a solo traveling exhibition at institute of contemporary art at maine college of art, art museum, bates college, art gallery of the university of north texas, art space, kansas art institute, kansas city.

translation & intersection - wenda gu's new installations, national gallery of australia, canberra, australia

nations-babel of the millennium, san francisco museum of modern art, usa

working in brooklyn, brooklyn museum of art, usa

the babel tower, national gallery of contemporary art, seoul, korea

first guangzhou triennial, guangdong art museum, guangzhou, china

duchamp, 49th venice biennale, venice, italy

3rd mercosul biennale, brazil

second biennale of asian contemporary art, museum of contemporary art, genova, italy

first chendu biennale, chengdu, china

duchamp, 7th international istanbul biennale, turkey

man & space, 3rd kwangju biennale, south korea

sharing exoticisms, 5th lyon beinnale, lyon, france

conceptualist art: points of origin 1950s-1980s, queens museum of arts, new york city, walker art center, minneapolis, miami art museum, florida, usa

inside out - new chinese art, asian art museum san francisco, museum of contemporary art, monterrey, mexico, henry art gallery, washington university, seattle, asia society, ps1 museum, new york city, usa

second shanghai biennale, shanghai art museum china

second johannesburg biennale, south africa

twentieth century chinese painting-tradition & innovation, the british museum, london, england, national art museum, singapore, hong kong museum of art

heart of darkness, the kroller-muller museum, the netherlands

silent energy, modern art museum, oxford, england

fragmented memory, wexner center for the arts, ohio, usa

mao goes popa, museum of contemporary art, sydney, australia

4th construction in process, the artists museum, history museum of lodz, poland

no u turn-china avant-garde, china national art museum, beijing, china

Wang Mansheng

MANSHENG WANG/MANSHENG WANG is from Taiyuan, a city in
north-central China. He began studying Chinese calligraphy and painting
on his own at an early age. Following graduation from the Classical Chinese
Literature Department of Shanghai's Fudan University in 1985, he worked
for over a decade as a director and producer of programs on Chinese and
Tibetan art and culture for China Central Television in Beijing.

In the tradition of China's gentleman scholars, Wang's primary motivation
for painting is self-cultivation. His paintings are often meditations on the
landscapes and images of China's past. A favorite theme is the lotus. The
Hudson River has been another source of inspiration. Wang enjoys the
expressive possibilities of ink and color on various types and textures of
paper. He has experimented with Chinese brush on porcelain and pottery
and, more recently, has begun using woodblock and other print techniques on
canvas and paper as well as working with oils.

Wang's calligraphy and paintings have been shown both in China and the
United States. He has held shows at the Beijing Art Museum in 1996, at
Wave Hill House Gallery in Bronx, New York in 2000, and at galleries in
Dobbs Ferry, Piermont, Pomona, Bronxville and Yonkers, New York, since
1999.

He has taught Chinese calligraphy at the China Institute in America in New
York City and Chinese painting at the Rockland Center for the Arts in Nyack,
New York. The Clay Art Center in Port Chester, New York and other pottery
studios have invited him to present workshops on painting on clay. In addition,
he has lectured on Chinese art and culture and given demonstrations of
his work at universities and museums. Some of his shows are: "Distant
Heart," "Change of Season," "Contemporary Chinese Images," "Interrupted
Meditations," "Works on Paper by Mansheng Wang," "Scudding Clouds,"
"Reflections on Tradition," and "Art and Artlessness."

Mansheng Wang resides in Dobbs Ferry, New York, with his family.

Xu Bing

Xu Bing was born in Chongqing, China in 1955 and grew up in Beijing. In
1975, he was relocated to the countryside for two years during the Cultural
Revolution. In 1977, he enrolled in the Central Academy of Fine Art in
Beijing, where he studied printmaking. He received an MFA from the Central
Academy in 1987. In 1990, he moved to the United States where he still lives,
making his home in Brooklyn, New York.

His work has been shown in the 45th Venice Biennial, Italy; the Museum
of Modern Art, New York; Museum Ludwig, Koln; The Reina Sofia Museum
(Museo Nacional Centro de Arte Reina Sofia), Madrid; the Victoria and
Albert Museum, London; Kiasma Museum of Contemporary Art, Helsinki;
Sydney Biennial, Australia; Kwangju Biennial, Korea; Johannesburg Biennial,
South Africa; National Gallery of Canada, Ottawa; San Francisco Museum
of Contemporary Art (MOCA); National Gallery of Australia, Canberra; ICC
– International Communications Center, Tokyo; P.S. 1, New York. He has had
solo exhibitions at the New Museum of Contemporary Art, New York; Joan
Miro Foundation (Fundacio Pilari Joan Miro a Mallorca), Spain; ICA (Institute
of Contemporary Art), London; National Gallery of Prague; the National
Gallery of Beijing; the North Carolina Museum of Art; the Cherng Piin Gallery,
Taiwan and the Arthur M. Sackler Gallery at the Smithsonian Institution in
Washington, D.C.

Over the years, Xu Bing's work has appeared in high-school and college
text-books around the world including Abram's Art Past, Art Present, and
Gardner's Art Through the Ages. In July of 1999, Xu Bing was awarded the
MacArthur Award for Genius by the John D. and Catherine T. MacArthur
Foundation in recognition of his "…originality, creativity, self-direction, and
capacity to contribute importantly to society, particularly in printmaking and
calligraphy." In September 2003 Xu Bing was awarded the Fukuoka Asian
Culture Prize for his work in Asian Art and Culture.

Zhang Hongtu

Zhang Hongtu/Hongtu Zhang graduated in 1969 from the Central Academy
of Arts and Crafts, Beijing, and moved to New York in 1982. He had
solo exhibitions in the New York area and Taipei since 1984 that include:
"Dialogue with the Taipei Palace Museum, Zhang Hongtu Solo Exhibition",
"Icon & Innovations: The Cross-Cultural Art of Zhang Hongtu" , "New
Paintings", "Repaint Chinese Shan Shui Painting", "Zhang Hongtu, New
Works", "Reflections Abroad: the Journey of Zhang Hongtu 1982-1996",
"Soy Sauce, Lipstick, Charcoal", "Chairmen Mao", "Zhang Hongtu: Material
Mao", "Material Mao", "The Angel's Ghost", and "In the Spirit of Dunhuang".
He also joined many group exhibitions in the US, China, Cuba, France,
Germany, and South Africa, such as: "Shuffling the Deck: The Collection
Reconsidered", "A Brush with Tradition: Chinese Tradition and Contemporary
Art" , "BQE", "Guangzhou Triennial", "Paris-Pekin", "Contemporary Brush
Strokes", "Cross+Overs", "Queens International", "Word and Meaning",
Unknown-Infinity", "China Without Borders", "Body Language", "Small World
- Small Works", "Beyond the Borders: Art by Recent Immigrant", "Teddy Bear,
Potato, Lipstick and Mao", "Changing Cultures", "Dismantling Invisibility", and
"Contemporary Artists". Zhang's works are collected by the Chinese National
Museum of Art in Beijing, Adams House of the Harvard University, The New
Museum for Contemporary Art (with Epoxy Art group) in New York, The Bronx
Museum of the Arts in New York, Princeton University Art Museum, and
many others. He has received many awards such as National Endowment
for the Arts, Visual Artists Fellowship from Washington, DC, Pollock-Krasner
Foundation Grant for Painting, and has been artist in residence in South
Africa, Hong Kong, and New York State Council on Art.

Bibliography

Bessire, Mark (ed.). *Wenda Gu: Art from Middle Kingdom to Biological Millennium.* Cambridge, Massachusetts: MIT Press, 2003.

Chen Guying (ed.). *Daojia wenhua yanjiu*–Studies on the Daoist Culture. Beijing:Sanlian Bookstore, 1997

Kristeva, Julia. *Powers of Horror: An Essay on Abjection*, New York: Columbia University Press, 1980

Leung, Simon and Janet Kaplan. "Pseudo-Languages: A Conversation with Wenda Gu, Xu Bing, and Jonathan Hay." *Art Journal*, v. 58, Issue 3 (Fall 1999): 86.

Lippard, Lucy. *The Lure of the Local: The Sense of Place in a Multi-centered Society.* New York: New Press, 1997.

Reckitt, Helena and Phelan Peggy (eds.). *Art and Feminism.* New York: Phaidon Press, 2001

Thomson, Belinda. *The Post-Impressionists.* New York: Phaidon Press, 1983

Wang Ying. *Zhongguo Guhua Jianshang* (Connoisseurship of Ancient Chinese Painting). Guilin: Lijiang Press, 1995 (in Chinese)

Xue Yongnian. *Jin Tang Song Yuan Juanzhouhuashi* (History of Scroll Painting of the Jin Tang Song and Yuan Dynasties). Beijing: Xinhua Press, 1991 (in Chinese)

Yan Sun is an assistant professor of art history at the Department of Visual Arts, Gettysburg College, Pennsylvania.

Wang Ying is an assistant professor of art history at the Department of Art History, University of Wisconsin-Milwaukee, Wisconsin.